NEATH
THROUGH TIME
Robert King

AMBERLEY PUBLISHING

Acknowledgements

I'm grateful to the following people have helped in various way by supplying me with photographs and other pieces of information: Margaret Gammon, Jan Davies, Margaret Pulman, Des Fowler, Barrie Flint, Peter Gittings, Terry Pulman, Redver Davies, Annette Davies, John Owen, Lil Saunders, Susan Elias, Pat Davies, Stuart Davies, John Mallon, to photographer, Mike Davies for all his help and encouragement, to Sarah Flight of Amberley Publishing for her guidance and tolerating my lateness and to Joy, my wife, for putting up with everything.

First published 2010

Amberley Publishing Plc
Cirencester Road, Chalford,
Stroud, Gloucestershire, GL6 8PE
www.amberley-books.com

Copyright © Robert King, 2010

The right of Robert King to be identified as
the Authors of this work has been asserted in
accordance with the Copyrights, Designs and
Patents Act 1988.

ISBN 978 1 84868 585 7

British Library Cataloguing in Publication Data.
A catalogue record for this book is available from
the British Library.

Typeset in 9.5pt on 12pt Celeste.
Typesetting by Amberley Publishing.
Printed in the UK.

Introduction

This collection of images of the town attempts to depict some of the changes that have happened over the last fifty or sixty years. Some of the pictures carry us back to the turn of the twentieth century some from the 1950s and 1960s. The latter period saw some dramatic alterations to the face of the area. In particular the 'old town' around the castle much of which is now a supermarket car park, notably the streets called Glamorgan Street, Russell Street, Cow Lane, Duck Street, James Street, the Latt have all disappeared. Cattle Street still exists in name but doesn't resemble its original incarnation.

Trying to capture pictures of the area as it is now proved difficult in some instances for three reasons: what replaced the old is often bland and not photogenic, on land where buildings once proudly issued a statement, is wasted and bare; and obscuring some of the old streets and areas are trees and shrubbery, which distract the photographer's art. Though, of course, the green additions, even in the centre of the town, are to be applauded.

What is noticeable is the demise of buildings that were built in the 1960s, the Civic Centre is an example, has already been demolished and a new building for our city fathers to work out of has been developed near the old site. The original area where the Civic Centre stood is currently a car park. This piece of land has been used as a rugby field and a fair field (it was called the Bird in Hand Field), what plans for its use in the coming decades we await with a degree of trepidation.

Water Street and the old Navvies Square have changed beyond all recognition. The old public houses have gone (only the Greyhound is still with us), the Victorian and Edwardian buildings have gone and have been replaced by huge metal and concrete structures that have no character. The old courts that were located on Water Street now sit as memories, like ghosts, under another type of court—where Magistrates dispense justice.

Most of the houses that are still on Water Street are now empty and await the attention of the demolition gangs. Windsor Road has fewer shops and Stockham's Corner has been altered to make way for the new road layout. Bridge Street, once the main access into the town is now a footway, the quayside is totally obsolete. Station Square, once so busy with buses departing to many adjacent towns and villages is characterless as is the railway station's façade.

All that said many older buildings are still with us and thrive housing more modern enterprise, the Parade has little altered, save for the new Blue Bell, Old Market Street has retained many of its features; Orchard Street's Gwyn Hall was all but destroyed by fire and a re-building project is ongoing.

The coalmines have disappeared from both the Dulais and Neath valleys in some instances to be replaced by modern factory units and in Cefn Coed's case, a small museum; the large houses have gone with only Rheola remaining. The addition to the area of the dual carriageway roads has to be seen as an advantage: many of us feared them but not too many today would ask to have them removed. The new A465 that cuts a swathe through the Vale of Neath has made vehicular communication easier and both the southern and northern links into the town from Skewen and Neath Abbey and Bryncoch and Cadoxton respectively have made life a little easier for people to enter the town.

I have included four chapters in this book: the Town, the Villages, the Valleys, and People and Places. The people and places heading I relish because it affords the opportunity, essentially to give a place for the record to the people who made the town what it is—a place I like to call, albeit a cliché, the centre of the world.

The Town

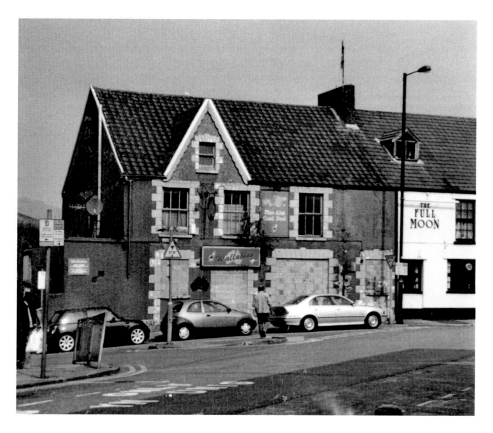

Blue Bell Public House
The once vibrant Blue Bell Public House on the Parade, sad, empty and bricked up and the new incarnation below, the recently opened four star hotel.

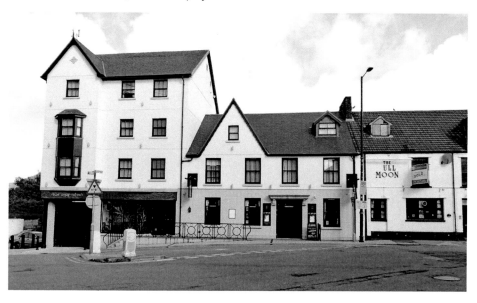

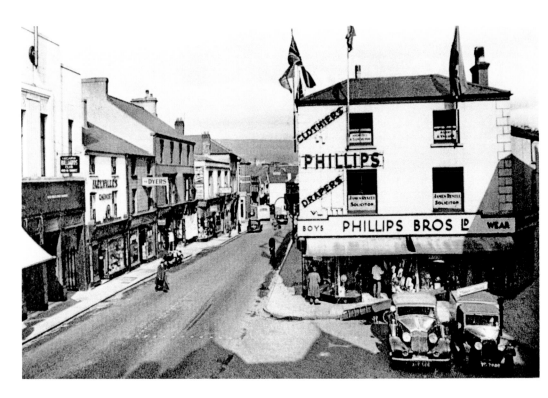

Phillips Bros Ltd

This 1940s photograph depicts the fashionable Phillips Bros Ltd on New Street bedecked with flags. The layout of the street hasn't changed a great deal but the kerbs on the road have been replaced by the fashionable paviers that merge both the pavement with the road.

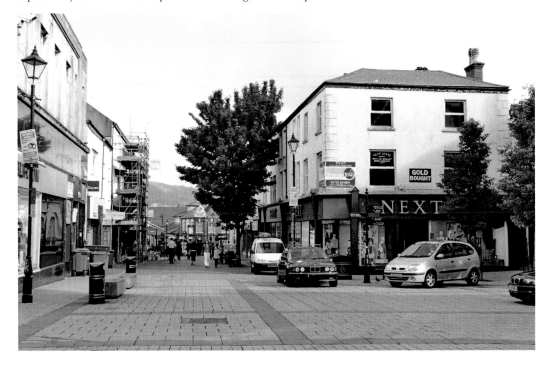

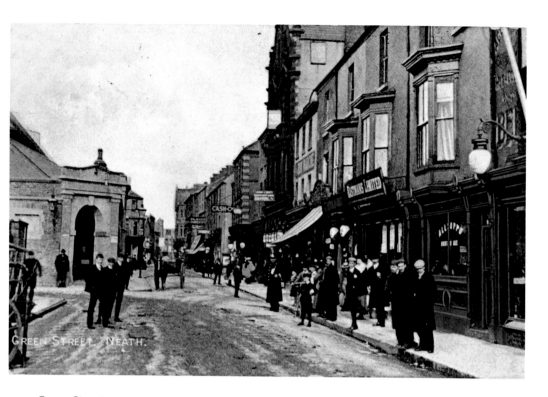

Green Street

Green Street *c.* 1900: the entrance to the market is unchanged; people clearly posing on the original image include a local policeman and young men dressed smartly in Edwardian clothes. The cart on the bottom left of the card above could indicate that it was market day in the town.

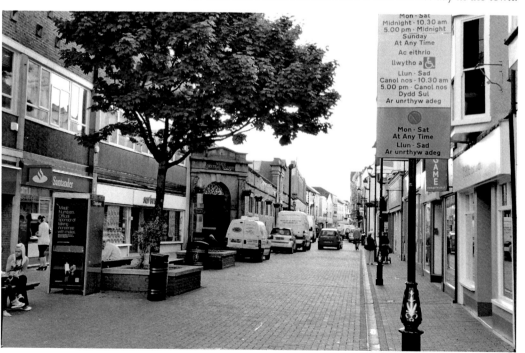

The Ancient Briton
The nineteenth-century public house, the Ancient Briton.

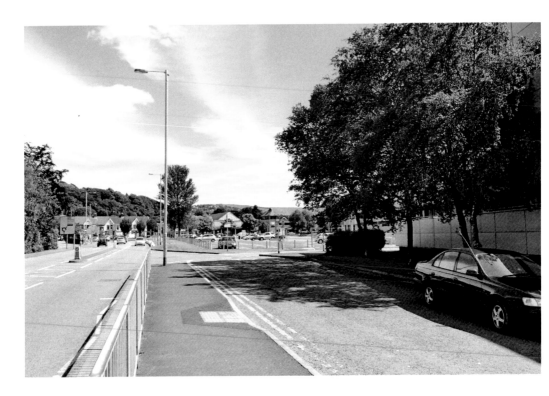

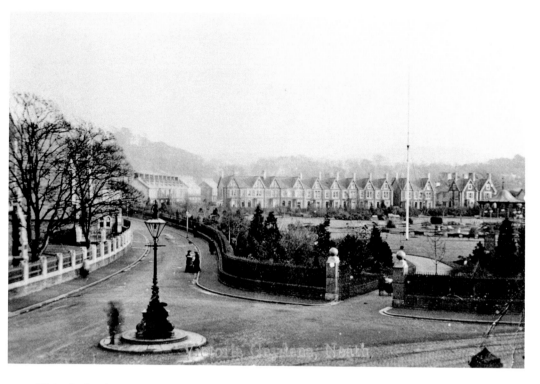

Victoria Gardens

A view of Victoria Gardens c. 1920s: the gas lamp in the centre of the road has gone and trees obscure much of the interior of the peaceful haven in the middle of the town.

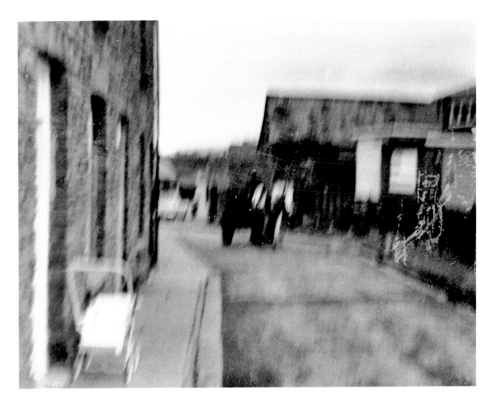

Cattle Street

This very old and blurred picture depicts Cattle Street before redevelopment. The image captures a shot of 'Arthur the Oil' delivering paraffin with his horse and cart. The area to the left of the photograph also housed Cow Lane and Duck Street. The photograph below shows the area completely changed.

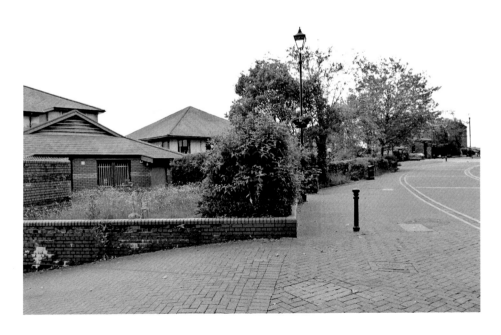

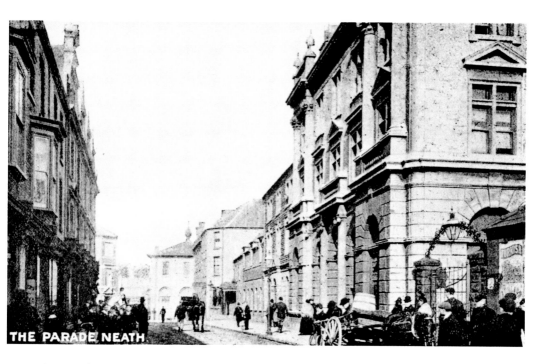

The Parade

This view of The Parade has hardly changed in a hundred years. The entrance to the Market is the same; the building now occupied by Barclay's Bank is unchanged. Now you can see only cars instead of horses and carts.

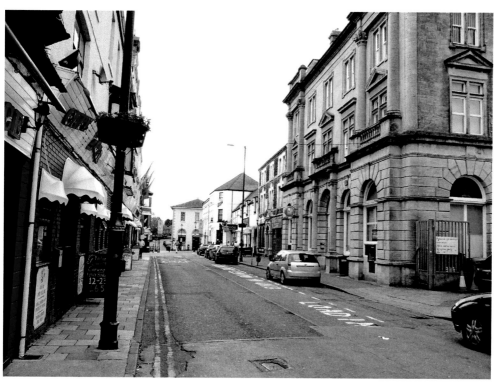

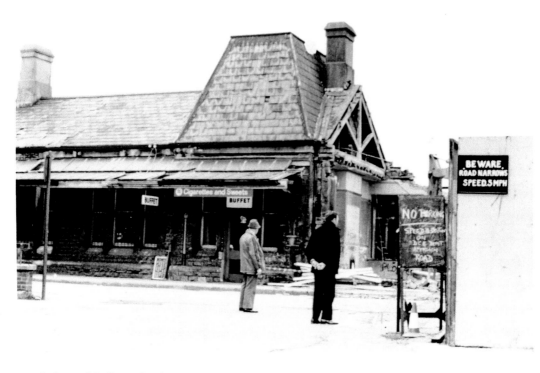

Neath General Railway Station
The demolition, some will say destruction, of Neath General Railway Station has started. This example of Neath's Victoriana is now replaced by bland buildings.

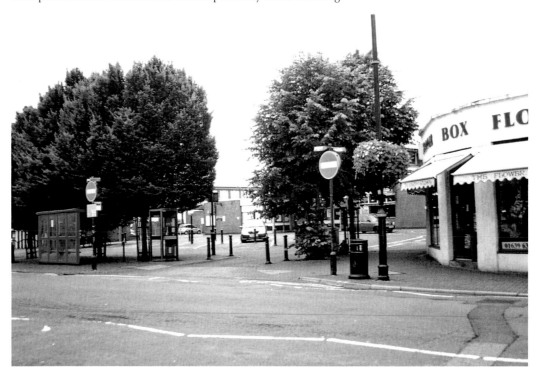

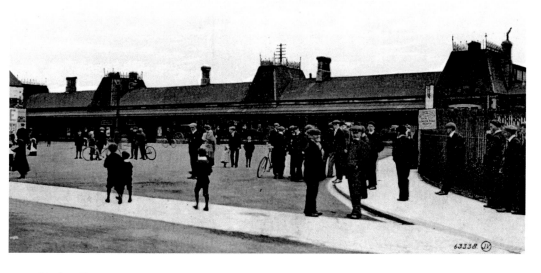

Station Square *c.* 1900.
And below the redevelopment of this part of town is complete.

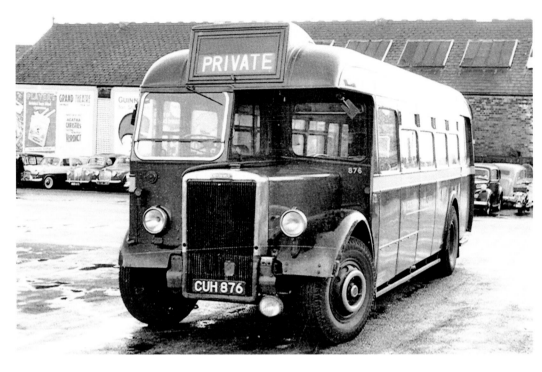

Neath Post Office
In the background the building is now occupied by Neath Post Office's sorting office. The Western Welsh saloon awaits a destination on Station Square in the late '50s early '60s.

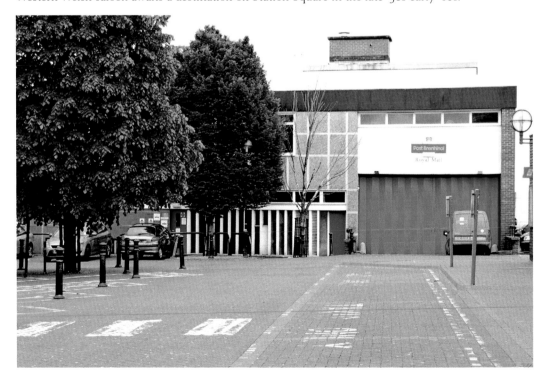

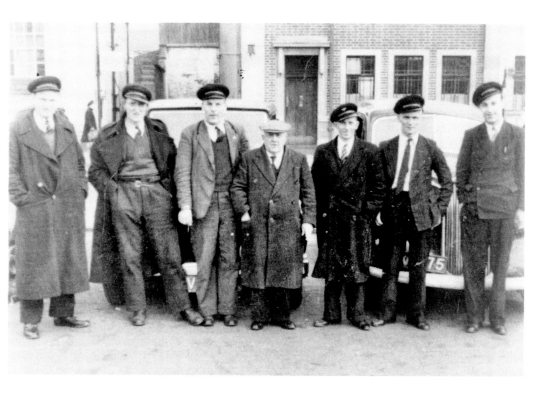

Station Square

A group of taxi drivers pose on their rank on Station Square. In the background is the old Police Station and Court Rooms. Below the police station has become a public house owned by the Wetherspoon's chain.

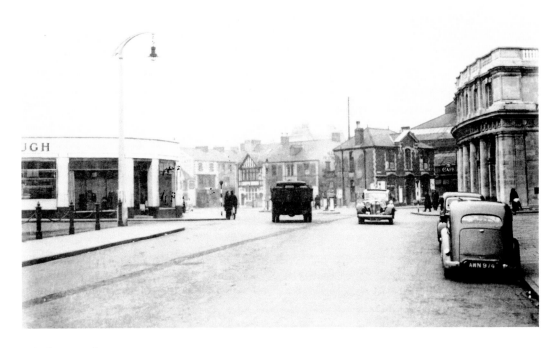

Windsor Road
Looking from the top of Windsor Road to The Parade *c.* 1940s: the station forecourt on the right. The National Westminster Bank also on the right looking down towards the mock Tudor frontage of the Market Tavern.

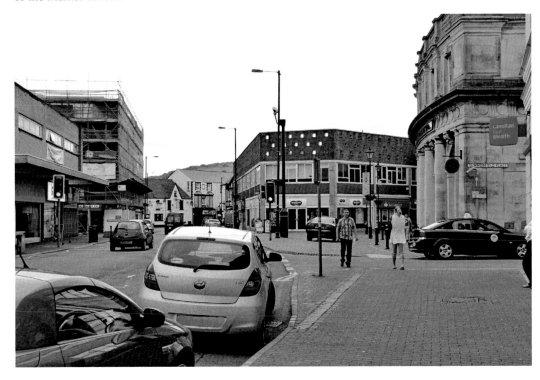

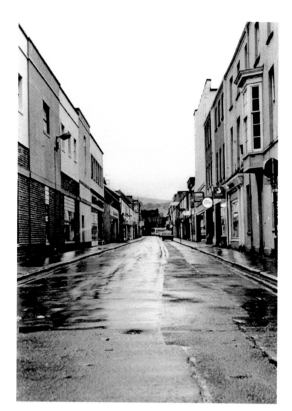

Queen Street
Queen Street looking towards Victoria
Gardens. This early '70s picture shows
the street before the red paviors were
laid.

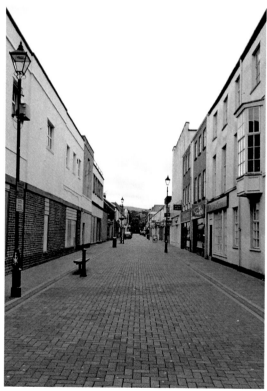

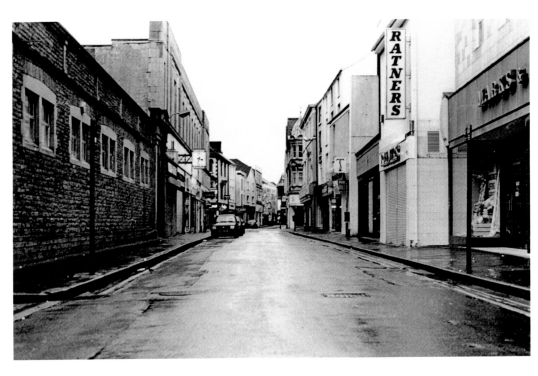

Green Street

Green Street, *c.* 1970, looking towards the Square and Wind Street. Marks & Spencer still has a presence in the town, on the left the clock on H. Samuel the jeweller's has gone but the company remains trading.

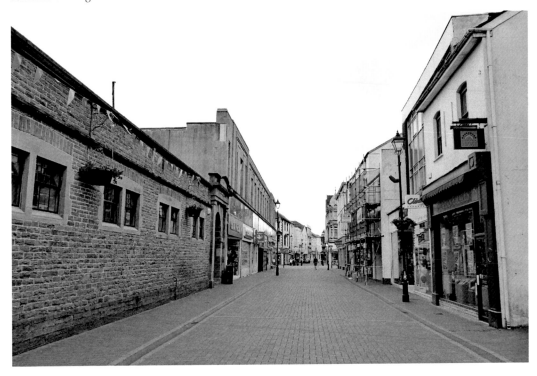

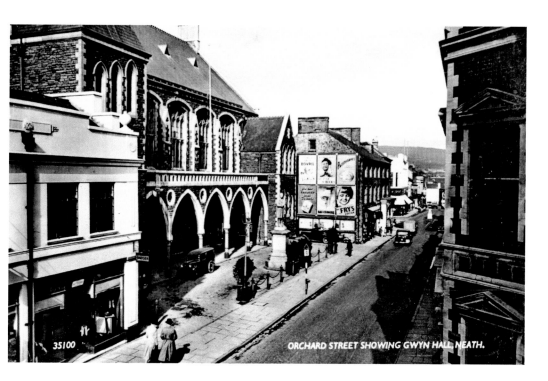

ORCHARD STREET SHOWING GWYN HALL, NEATH.

Orchard Street

Orchard Street, *c.* 1950, showing the Gwyn Hall on the left with the statue of Howell Gwyn yet to be moved to Victoria Gardens. Below, sadly the Gwyn Hall's remains following the fire in 2008 is shuttered as redevelopment work continues.

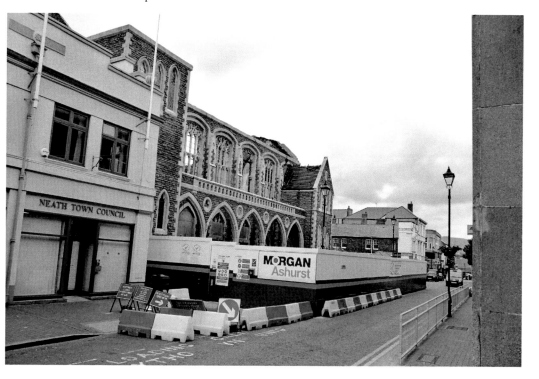

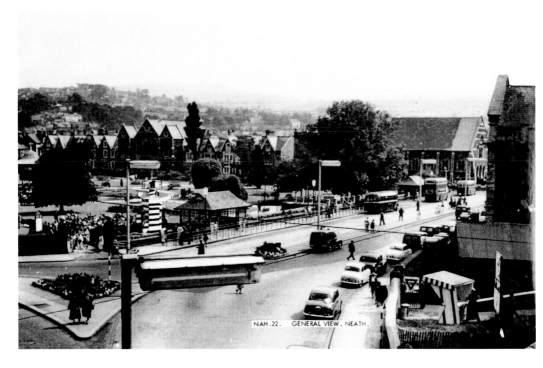

NAH.22. GENERAL VIEW. NEATH.

Victoria Gardens

A 1960s view of Victoria Gardens. The Victorian ornamental triangle is still to be seen on the left; Wesley Chapel, now the site of a doctor's surgery, had yet to be demolished.

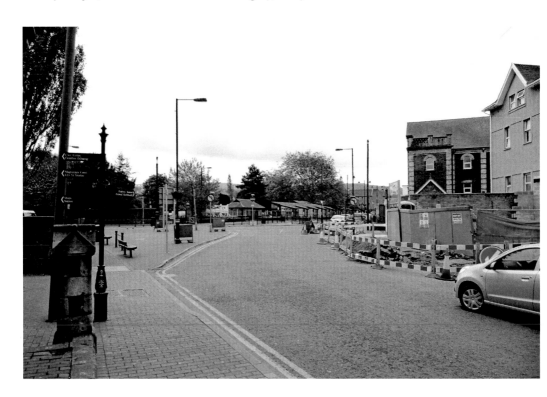

St Thomas' Church
St.Thomas' Church, originally the Castle's garrison chapel.

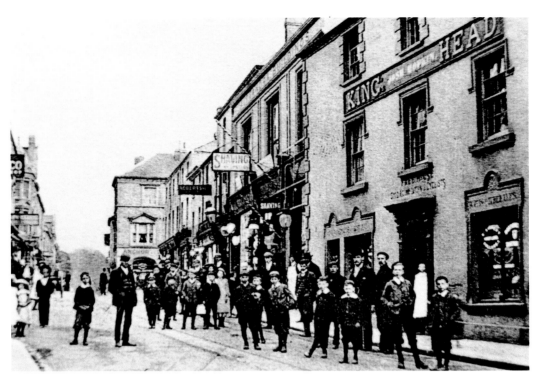

The King's Head
View of the King's Head public house on New Street c. 1910. In the middle of the picture is the Anchor public house. The façade of the windows on the latter is relatively unchanged.

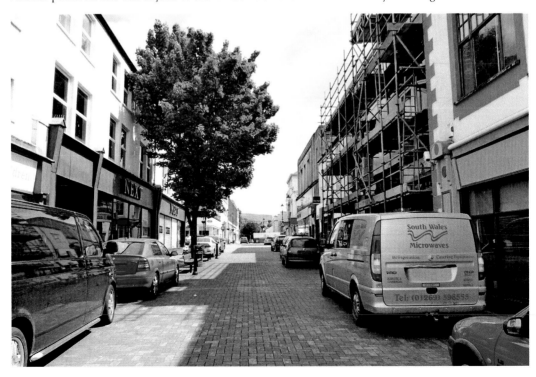

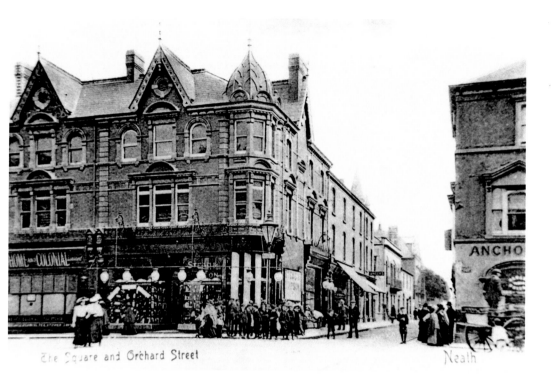

The Square and Orchard Street Neath

The Square
The Square c. 1910: the façade of the shops has changed little: on the right of Home and Colonial
is Stead & Simpson, still trading in the town.

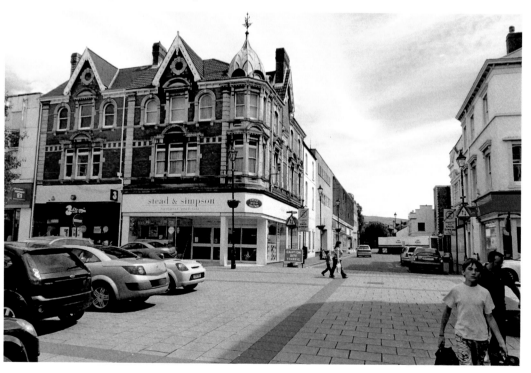

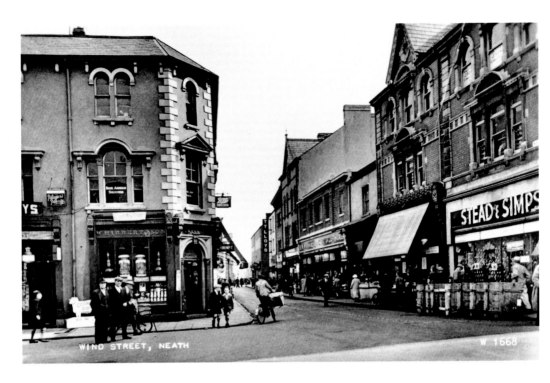

Wind Street

Wind Street, off the Square *c*. 1940. Stead & Simpson is still there, next door the Home and Colonial has long gone; the building occupied by F. W. Woolworth has been extended to accommodate another storey. The site of Woolworth's is now the Pound Shop; opposite is the chemist's showing the large, glass storage jars.

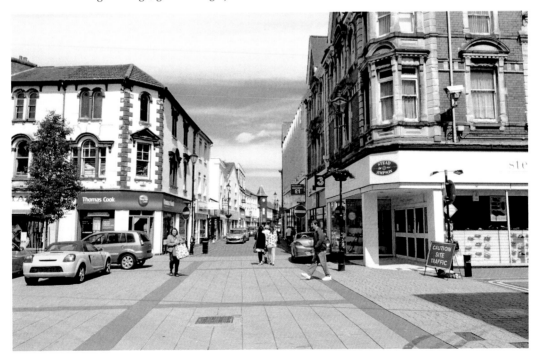

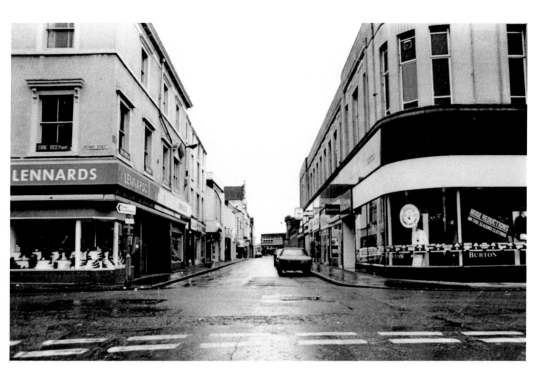

Green Street
Green Street from the Square looking towards the top of Windsor Road, early 1970s.

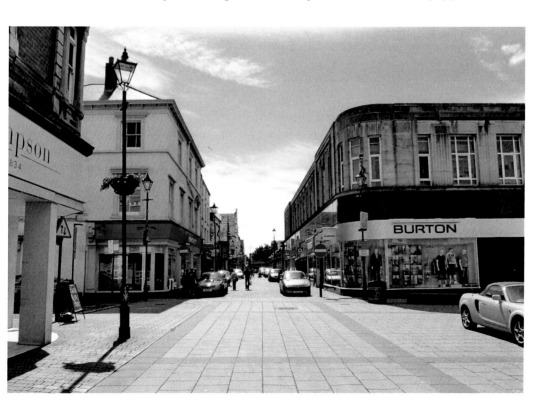

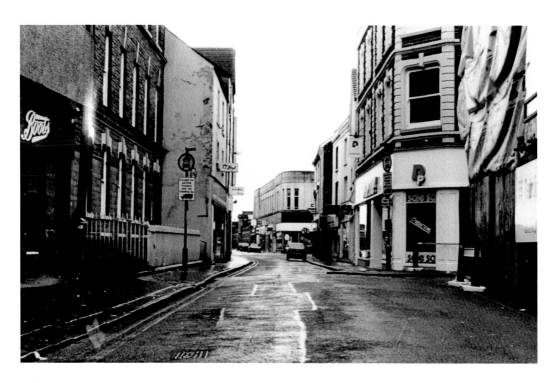

Wind Street

Wind Street, early 1970s: iconic shops like T. T. Lloyd still had a presence in the town; on the right of the picture the site of Whittington's stationers and printers is being redeveloped.

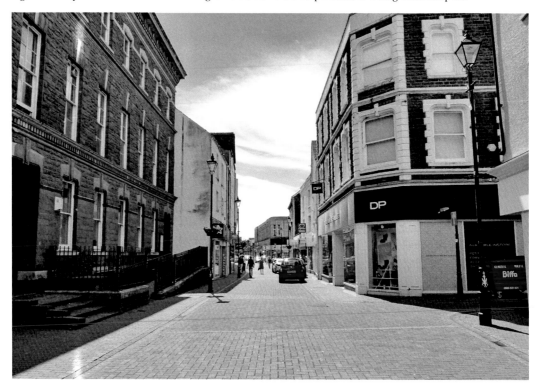

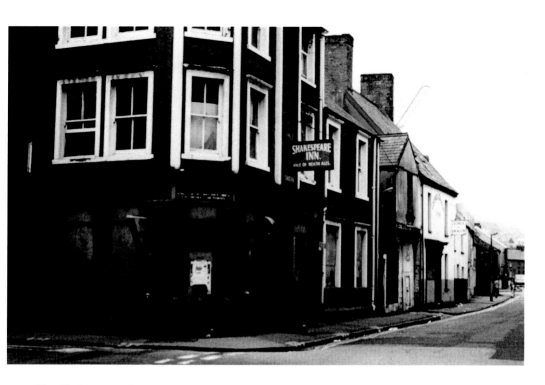

The Shakespeare Inn

The Shakespeare Inn on the corner of Water Street all boarded up in the early 1970s together with most of the properties in this part of the street. They made way for the multi-nationals like Wilkinsons and Tesco stores.

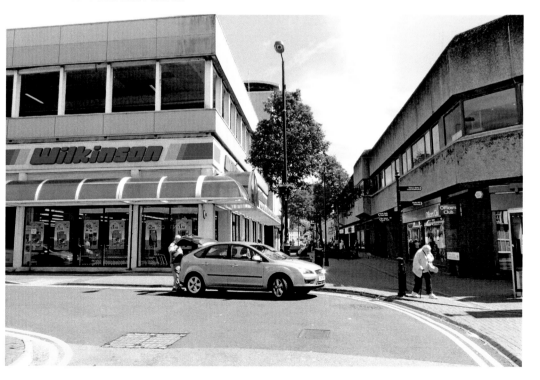

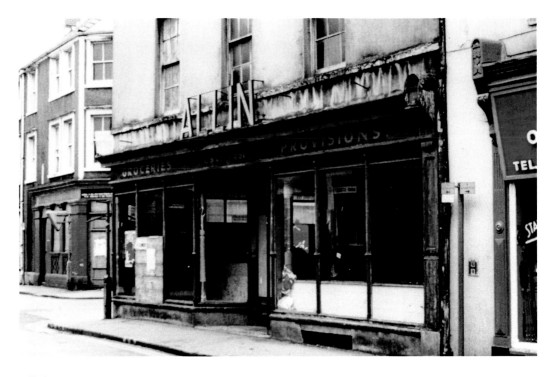

Allin's

The once up-market grocer, Allin's was located on the corner of Wind Street. In a slower age ladies would be offered seats to sit on and chat with each other whilst their orders were prepared. Now it is the site of Boots the Chemist.

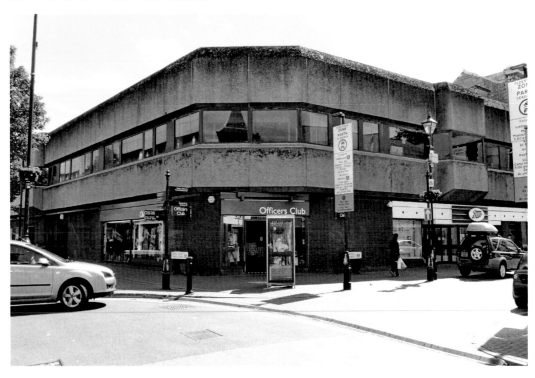

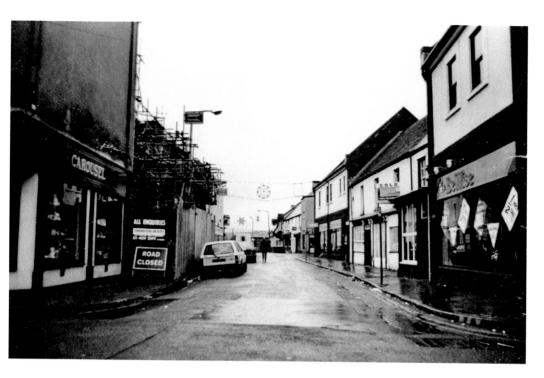

Old Market Street
Looking down Old Market Street from the corners of Wind Street and Water Street, *c.* 1970s.

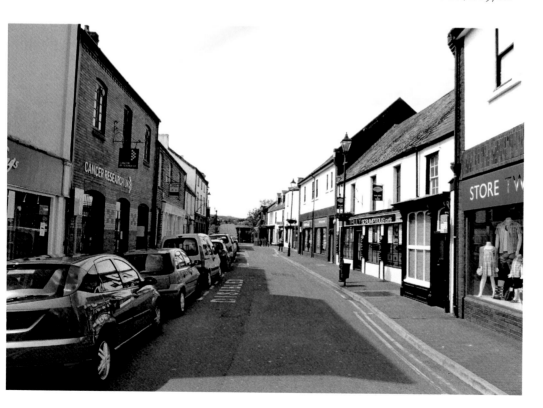

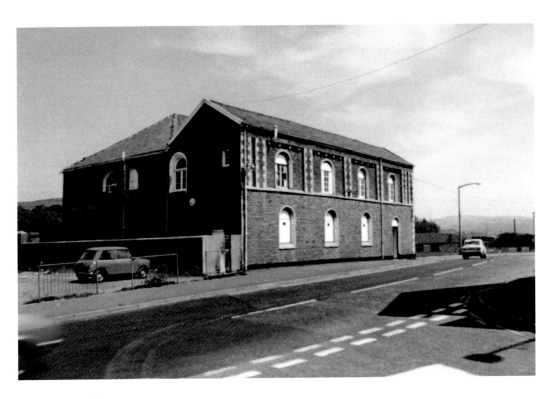

The Moose Hall

The Moose Hall in the 1970s. The building has had various incarnations: it has been used as a Methodist church, a Catholic church and a Fire Station. You can also see the road junctions of Cattle Street and Old Market Street before traffic restrictions.

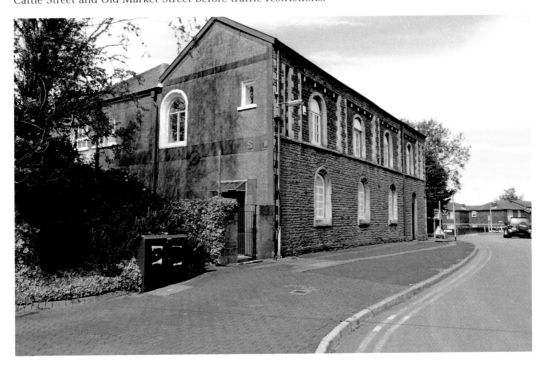

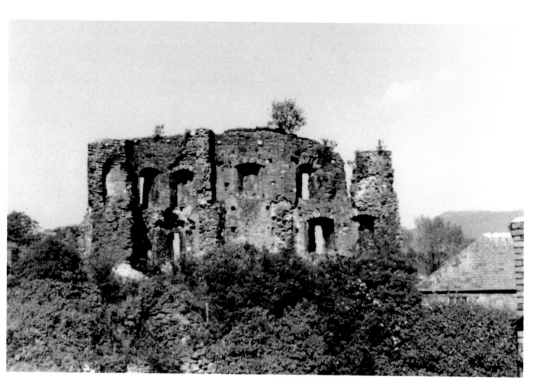

Neath Castle
Neath Castle in the 1970s.

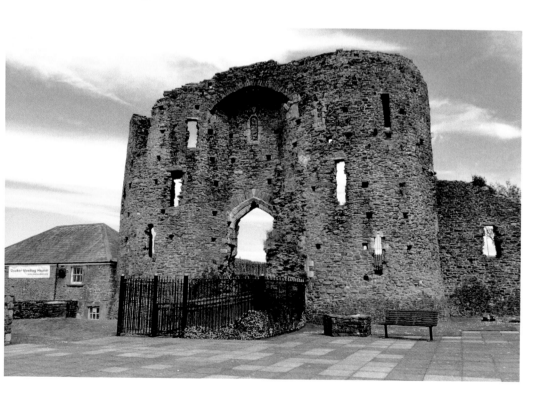

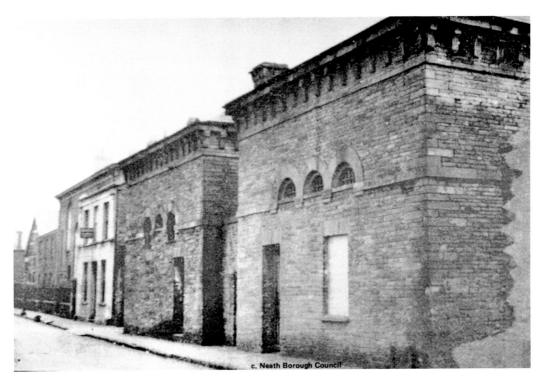

c. Neath Borough Council

Neath Jail

James Street has completely disappeared under a regeneration project. This image shows Neath Jail on the street, on the left of the picture stood Bethlehem Green Chapel. The street is now under the development of a supermarket car park.

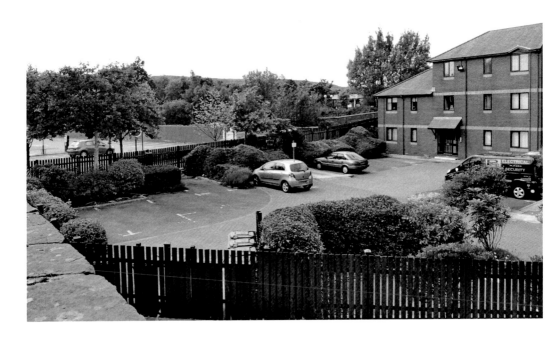

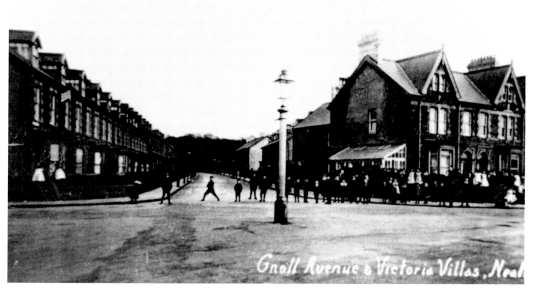

Gnoll Avenue

Gnoll Avenue in the first part of the 1900s. The houses are little changed. The houses on the right are on Victoria Gardens and the chimneys have gone and a conservatory has been added. The gaslight column in the centre of the road displays the level and speed of traffic. Horse and carts would not have demolished it.

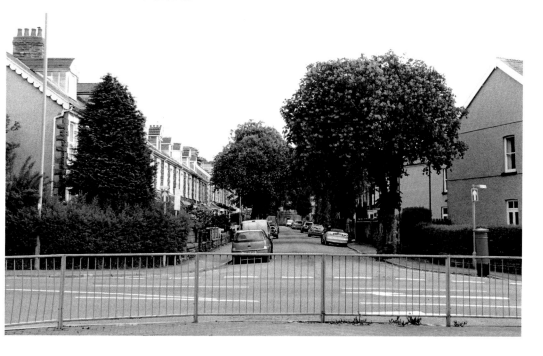

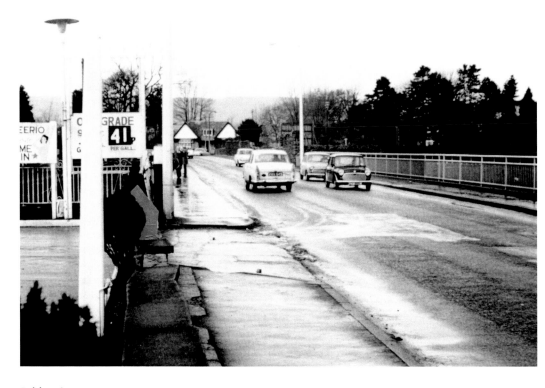

Bridge Street

Bridge Street early 1970s. It was used by two way traffic, now only pedestrians can access Neath Abbey Road and Cadoxton Road via this ancient route. Gillard's garage is on the left and the Glamorgan educational offices at the top of the picture.

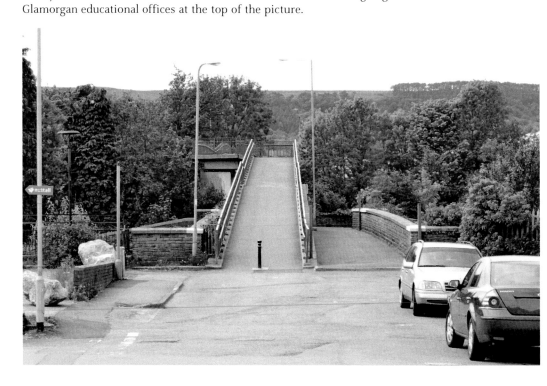

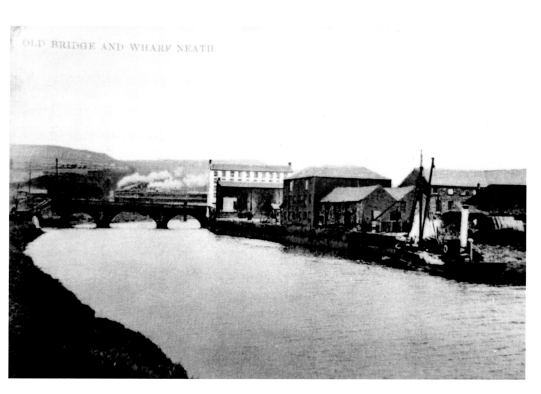

Towards Bridge Street
Looking towards Bridge Street: the white multi-storey building is Isaac Redwood's leather house or tannery; the Neath bridge with its wharfs and a full tide. The modern picture has the tide at low ebb. Some of the ladders, rings and chains, once used to hold the docked ships steady, are still to be seen.

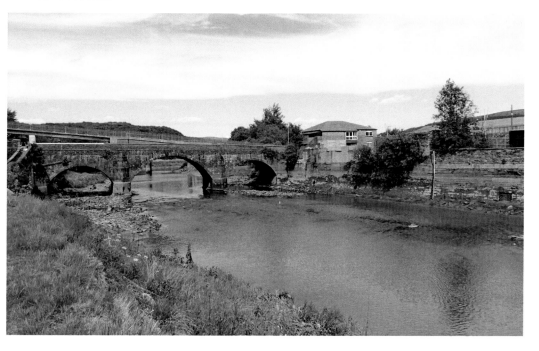

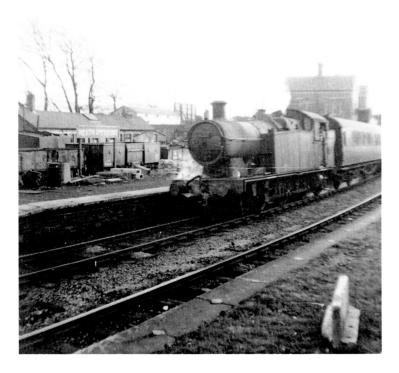

Neath Riverside Station

A train arriving at Neath Riverside Station in the early 1960s. Once a vibrant place with people arriving and departing for the Dulais Valley. The modern picture is sad in comparison showing a single track and a lonely signal box.

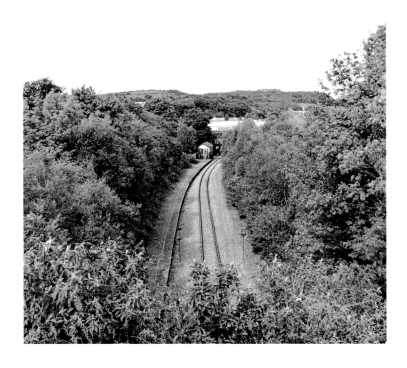

Villages

Neath Abbey Village
Neath Abbey village from Court Herbert. The picture *c.* late 1970s shows the late Cllr Brian Hall with the Shell garage, Abbey Services, once the site of Stan Young's garage. On the extreme left of the picture is the site now developed by Tesco Stores.

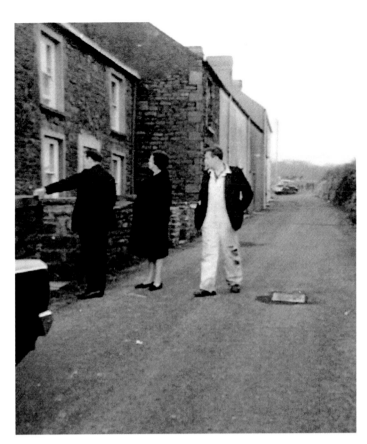

Taillwyd Road
Taillwyd Road, Neath Abbey before it was widened and bungalows were built on the right hand side. This picture shows Ken Davies, in the white overalls and Cyril and Gladys Davies.

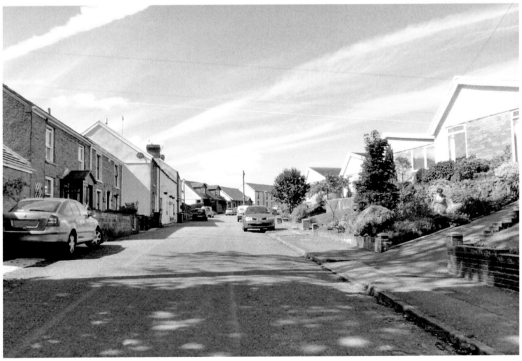

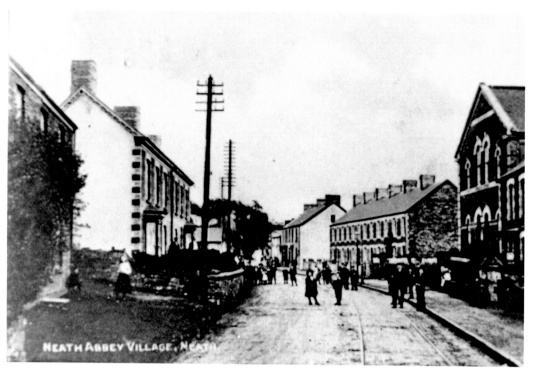

Neath Abbey Village

A view of Neath Abbey village *c.* 1910. The tram tracks are to be seen in the road, Ebenezer Chapel still stands. Below shows the area today with the road modernised and the chapel demolished.

Wesley Chapel

Wesley Chapel *c.* 1980s in Neath Abbey. Below the scene today, the chapel gone and new flats in its place.

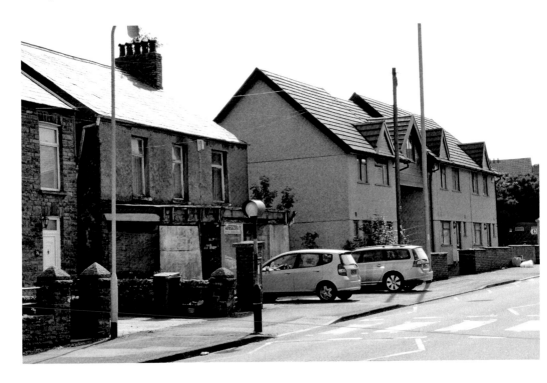

Skewen Greyhound Stadium

A picture of the Skewen Greyhound Stadium, locally called the dog track. Greyhounds have been raced here since the 1930s. Now the sport is virtually defunct in South Wales. In Skewen the site has now been developed for housing.

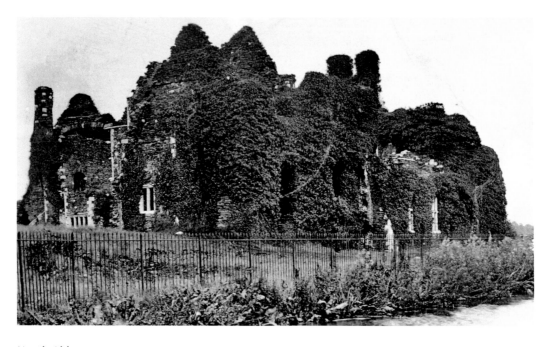

Neath Abbey

The ivy clad Neath Abbey ruins in the early years of the twentieth century. Below, a hundred years on and we are clearly more respectful of our ancient monuments.

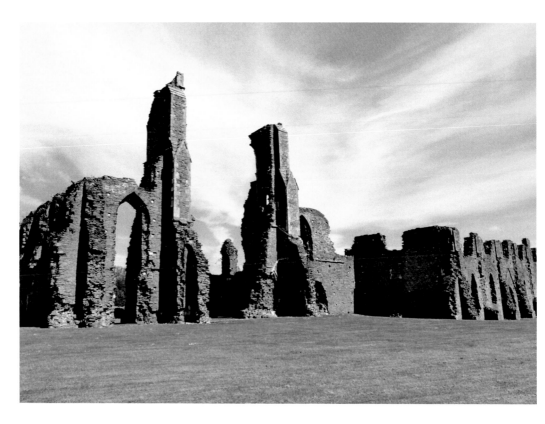

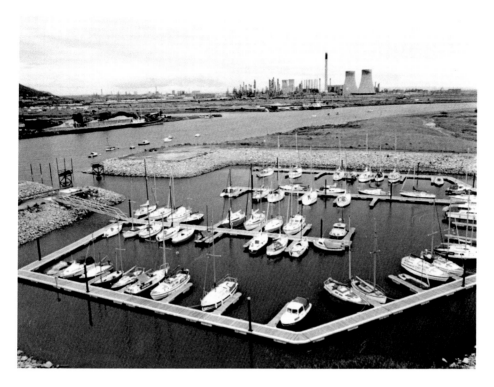

The Monkston Marina

The Monkston Marina on the River Neath near Jersey Marine. This 1980s picture depicts the BP complex at Baglan Bay in the foreground. Below the growth of trees obscures some of the scene together with the new Neath River bridge crossing.

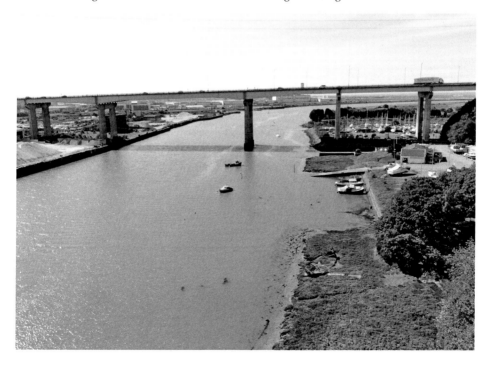

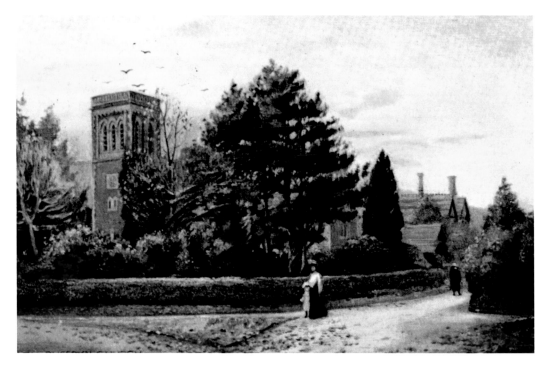

St Matthew's Church

The pastoral setting of St Matthew's Church, Dyffryn, Bryncoch in the 1900s. Today trees obscure much of the scene but you can see the chimney of the Old Vicarage (now called Swiss Gables) through the foliage. A hundred years on the area is still peaceful.

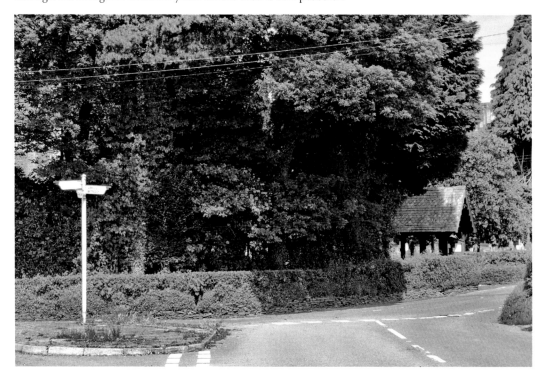

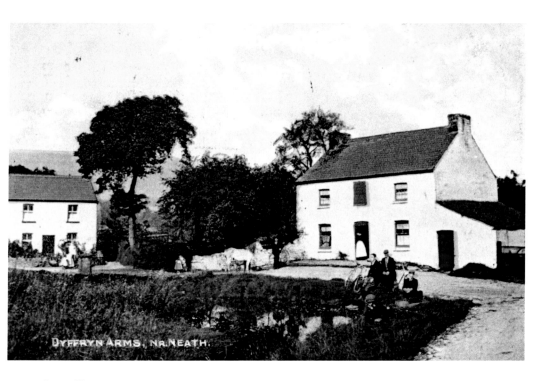

The Dyffryn Arms

The Dyffryn Arms, *c.* 1900, Bryncoch. Today the enlarged pub is a popular eatery. The pond is now a car park and Slebech Cottage, to the left, is relatively unchanged.

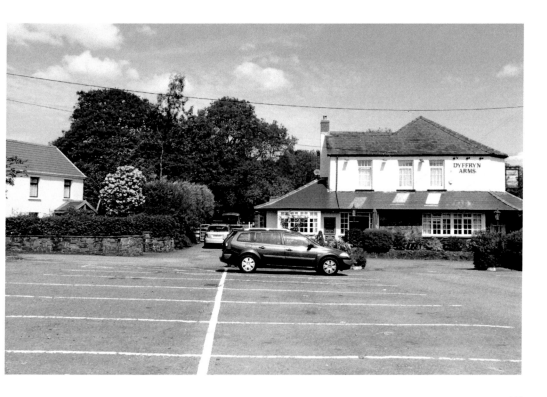

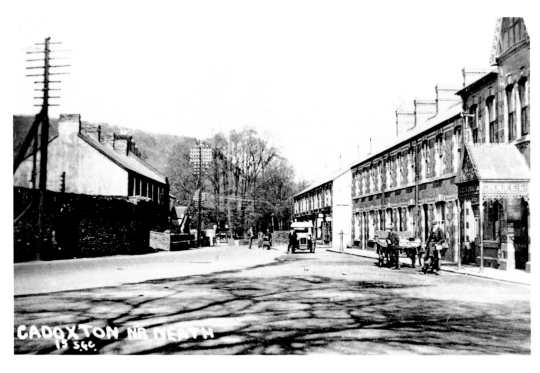

Cadoxton Village
Cadoxton Village *c.* 1930s. Today the scene depicted is much the same save for road alterations.

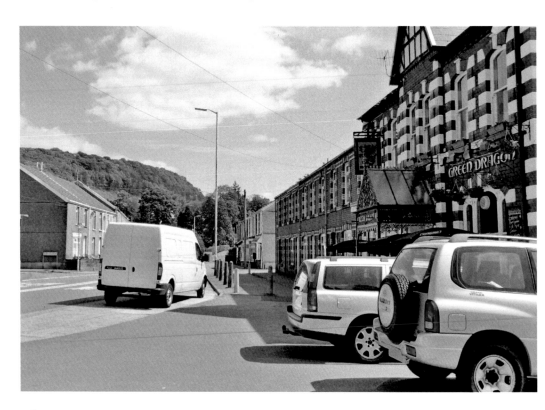

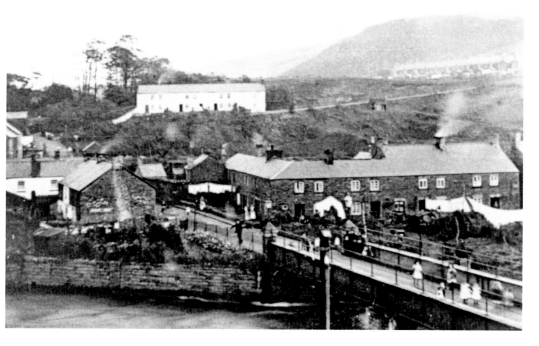

Aberdulais Village

This image of Aberdulais village bears no resemblance since the road developments. Access to the view above is by a footpath underpass under the new A465. The picture below captures the Dulais Rock public house sadly boarded up. Hopefully it will once again function as a hostelry.

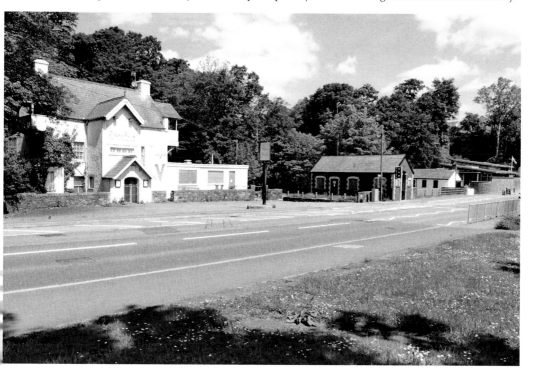

Aberdulais Falls
Aberdulais Falls and ironworks, before
the National Trust successfully turned the
site into a commercial tourist attraction.

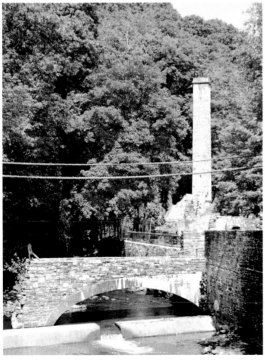

The Valley Area

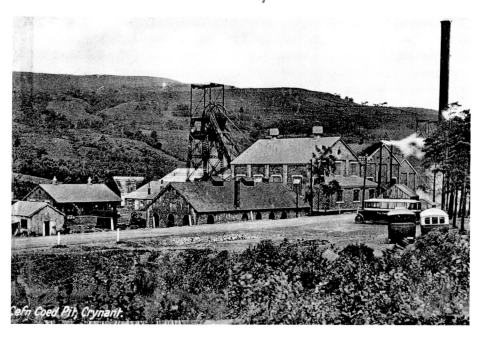

Cefn Coed Colliery
An early picture of Cefn Coed Colliery near Crynant. Now only remnants of the buildings remain save for a section that houses a small industrial museum.

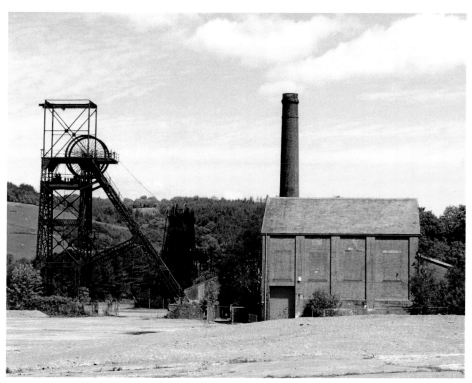

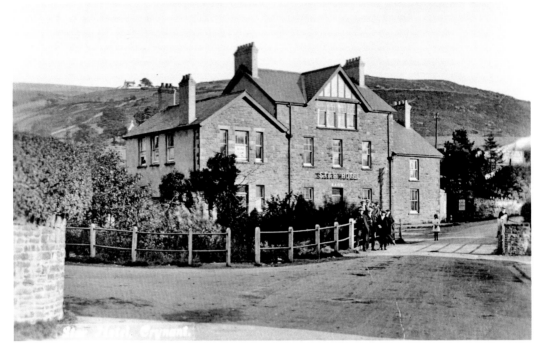

The Star Hotel
The Star Hotel on the Square, Crynant, *c.* 1920s. Today the hotel is a dwelling, the road has been widened and trees and shrubs cover the scene from a hundred years ago.

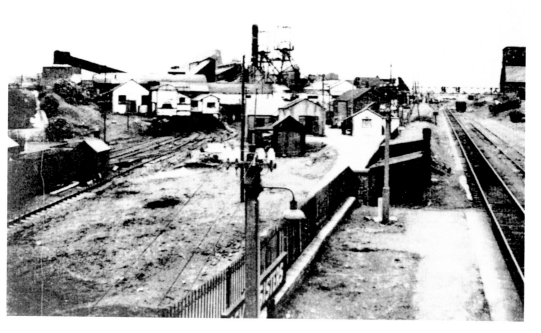

The Seven Sisters Colliery

Another busy industrial scene, the Seven Sisters Colliery *c.* 1950s and the railway station. The railways still exist but only as a mineral line. All that remains of the colliery is a winding wheel displayed for tourists.

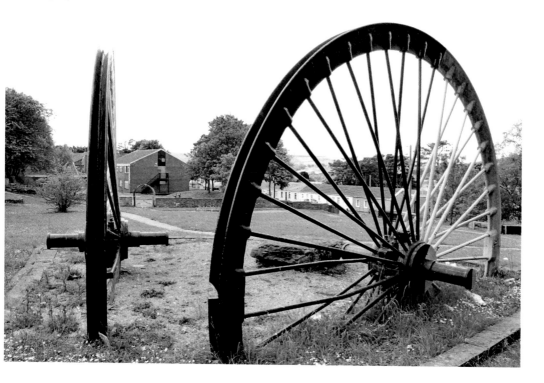

The Onllwyn Inn
The Onllwyn Inn pre-1960s. Now demolished, with the site a parcel of waste ground.

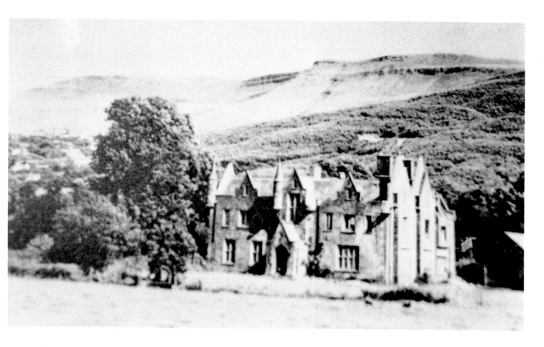

A Lost Mansion

One of the lost mansions of the Vale of Neath, Maesgwyn *c.* 1950. The poet Robert Southey had ambitions to live here in 1801, but he couldn't agree a lease with Squire Williams. If he had lived in this house the School of Romantic Poets (The Lake Poets) could have been called the Bards of Cwm Nedd. Now the site of the house is occupied by a bungalow, which is obscured by trees.

Rheola Racecourse

Rheola Racecourse in the early 1990s. The fences await competition from point-to-point racehorses. Now the site is a watery haven for wildlife and enthusiasts of watersports as seen in the picture below.

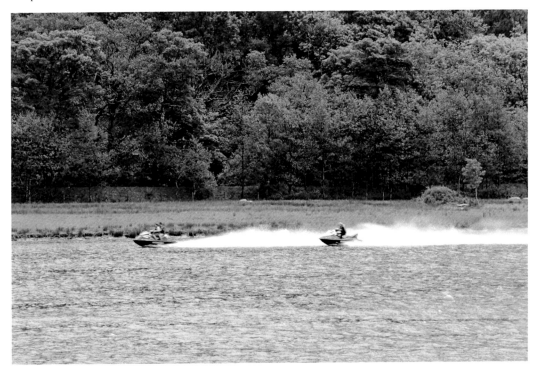

People and Places

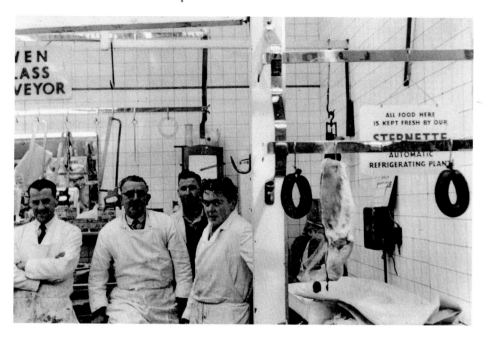

The Flying Butcher

Butcher, Ken Owen in centre of picture, in his shop in the Neath Market in 1963. Ken was known locally as 'The Flying Butcher' because he delivered meat on his motorcycle in and around the town. He started his business in the market in 1935. On the extreme right of the picture is his son, David. The picture below is taken in May 2010 and features the late Ken Owen's youngest son, John, on his last day in business. Ken Owen & Sons ceased trading after a period of seventy-five years.

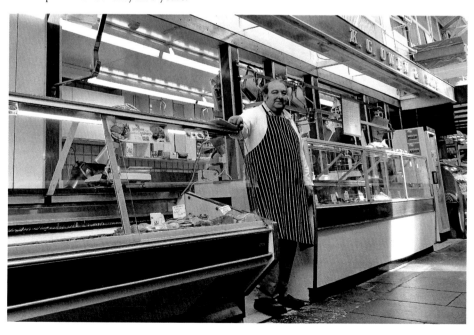

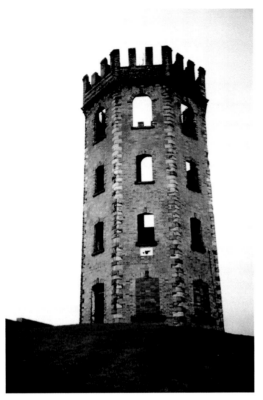

Jersey Marine
The camera obscura at Jersey Marine in the picture above is open to the elements, below the building is transformed into bedrooms as part of the Tower Hotel complex.

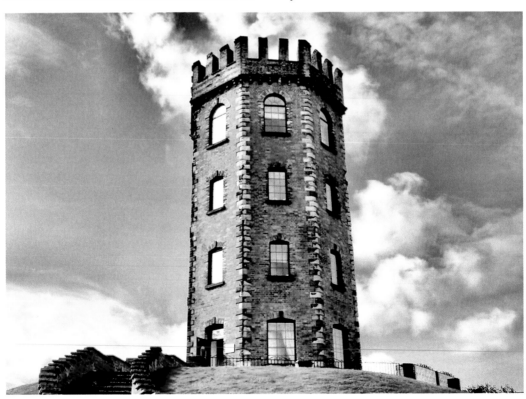

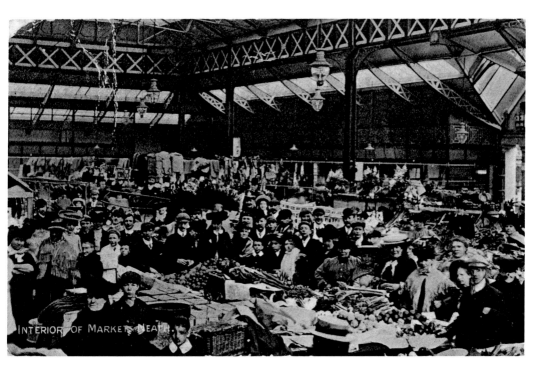

Market Hall and Ebenezer Chapel
The interior of the Market Hall *c.* 1910. Below, dominating the village in its heyday, is Ebenezer Chapel, Neath Abbey. It has now been demolished.

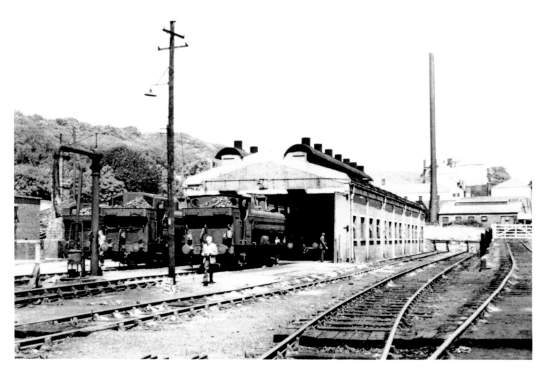

Neath Riverside Station and Ladies' Club Christmas Play

A scene at the Neath Riverside Station *c.* 1950s. In the background you can see the Neath Brewery. Below, members of the Ladies' Club, Longford perform their Christmas Play in the Longford Memorial Hall during the 1960s.

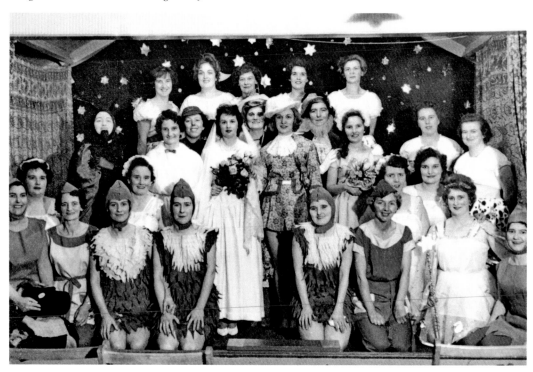

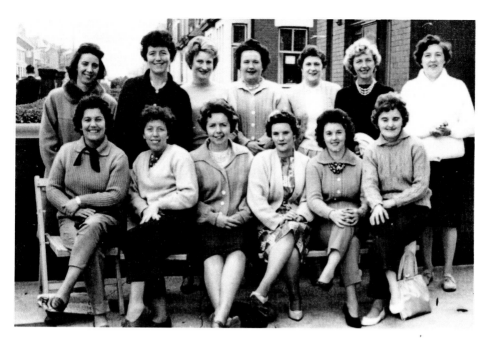

Members of Longford Ladies' Club on a trip to Blackpool, *c.* 1970
L to R: Back row: B. Morgan, J. Morgan, Val Ball, R. Evans, G. Griffiths, J. Thomas, L. Jones. Front row: Lil Saunders, P. Brown, B. Hancock, J. Webb, N. Jones. B. Isaac. Below is the Resolven Scouts Gymkhana in 1970. Pictured are standing from the left: Islwyn Jones, Bill Carey, Mrs Hetty Ann Jones, Ossie Jones, Leu Evans, Doug James.

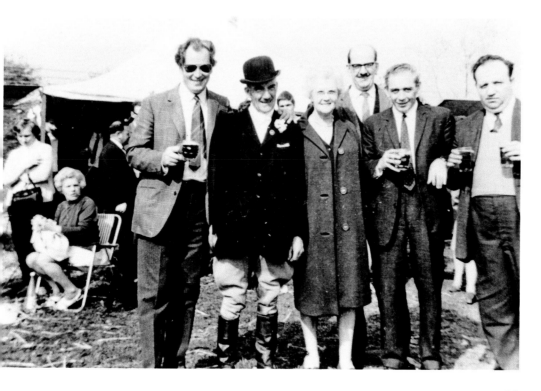

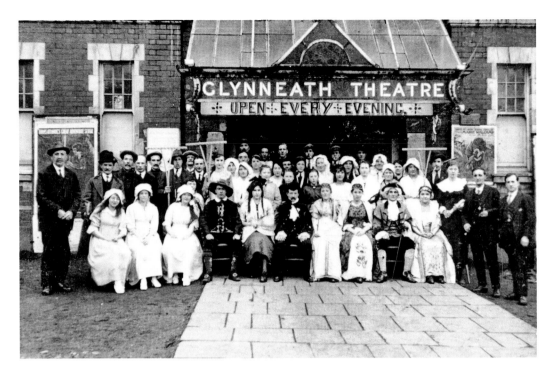

Glynneath Theatre

Members of the Glynneath Theatre. Below we can see a Whit Sunday march along Windsor Road in the 1970s.

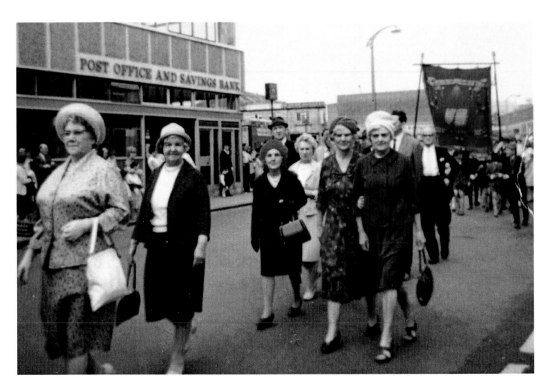

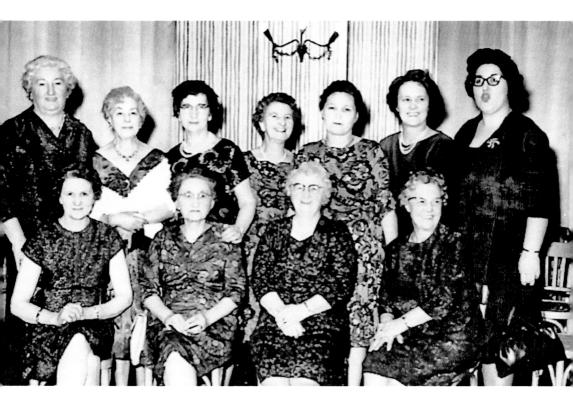

Briton Ferry Townswomen's Guild

Members of the Briton Ferry Townswomen's Guild at their annual dinner in the Beach Hotel, Port Talbot in January 1965. Below is a march along Windsor Road, *c.* 1920s.

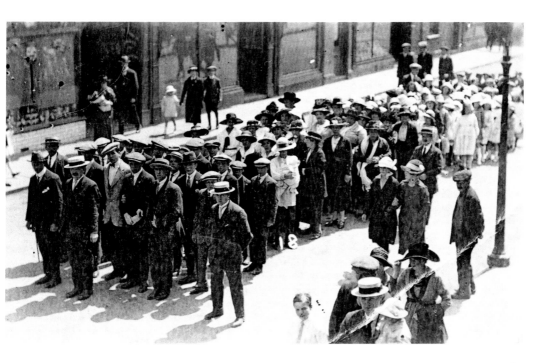

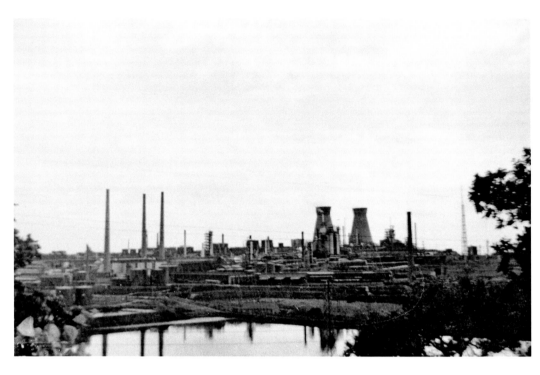

National Oil Refinery and Neath Club Outing

National Oil Refinery showing the cooling towers *c.* 1958. Below shows members of a Neath club on their annual outing. Note the N & C (Neath and Cardiff) coach in background.

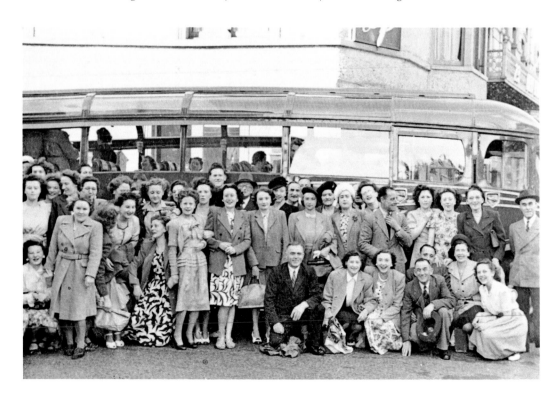

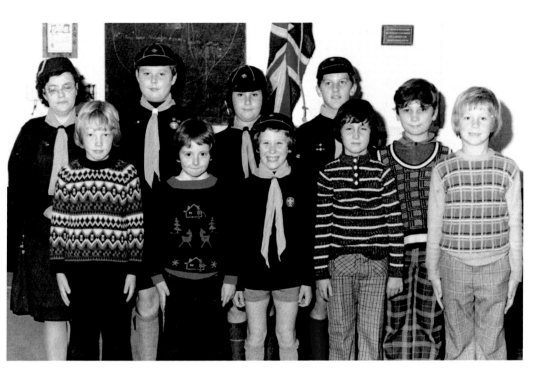

Scouts and Milers

Members of the 3rd Neath Cub Scouts pose for this picture in 1977. The photograph below shows Bryncoch Milers stepping out along Main Road, Bryncoch for the MacMillan Nurse Appeal on Thursday 11 June 1992.

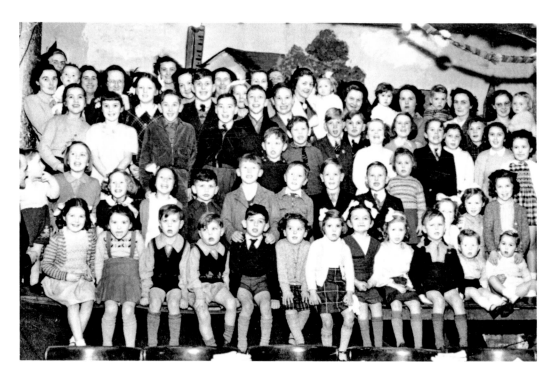

Smile Please!

The N & C (Neath and Cardiff) Luxury Coach Christmas Party celebrated in 1952 at the Central Club on London Road, Neath. Below, NOR (National Oil Refinery) Bowling Team pose for this celebratory picture in 1949 as winners of West Wales and South Wales Private Greens Championship.

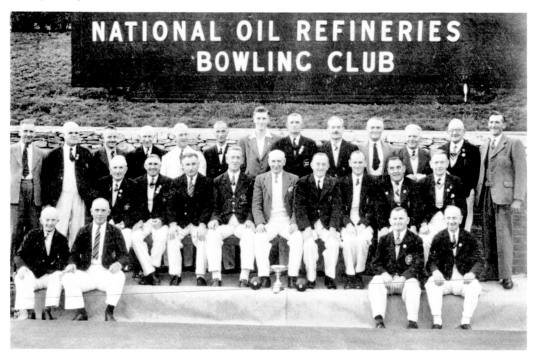

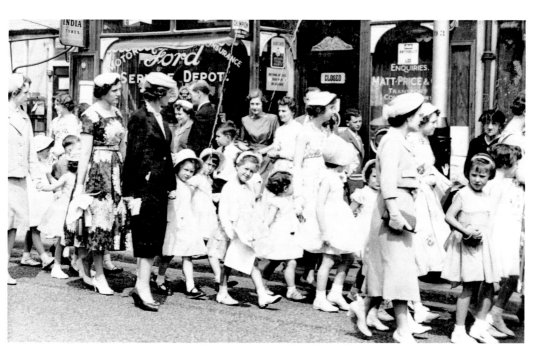

Celebrations and Performances
Smiling children marching on possibly a Whit Sunday around the thoroughfares of the town. In the photograph below are members of Neath Townswomen's Guild, *c.* 1970s.

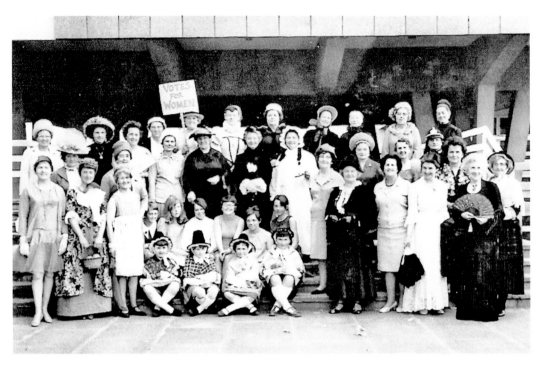

Neath Civic Week and Youth Exchange
Residents celebrating Neath Civic Week in the 1970s pose outside the now demolished Civic Centre. Below, members of the Youth Exchange pose in the Neath Little Theatre, c. 1960/1961.

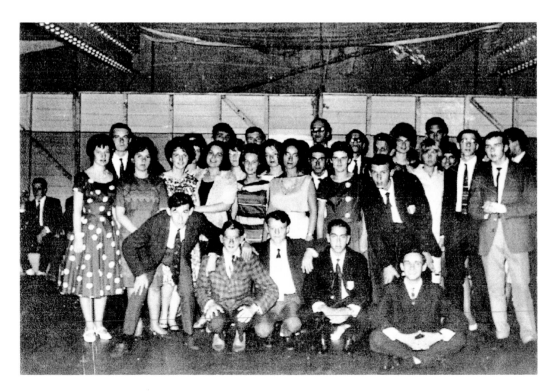

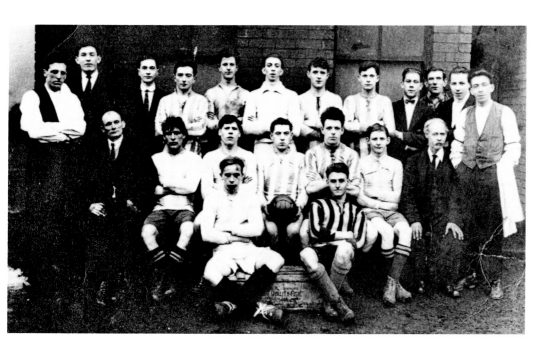

Clyne Tinplate Works AFC in 1924/25
I. Lewis, S. Rees, C. Bevan, A. Davies, O. Jones, T. Williams, E. Jones, S. Roberts, E. Bartlett, A. Elliott, I. Harris, D. Jones. Middle Row: J. Roberts, D. James, C. Hoare, D. H. Llewellyn, E. D. Jones, D. R. Hopkins, D. J. Hopkins. Seated in front: J. Pugh and E. Hopkins.

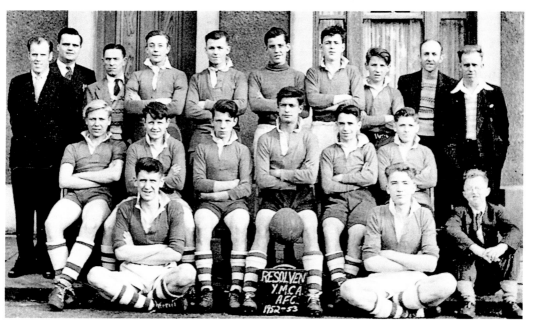

Resolven YMCA AFC in season 1952-53
M. Stock, Don Fearn, Dai Vaughan, J. Jarvis, D. Williams, Albion Stock, Billy Church, J. Harris, Bob Stock, Alf Stock. Middle row: G. Smith, C. Hiles, B. Gittings, C. Church, I. Llewellyn, J. Hadley. Seated in the front row: Peter Llewellyn, Peter Hopkins, Royston Stock.

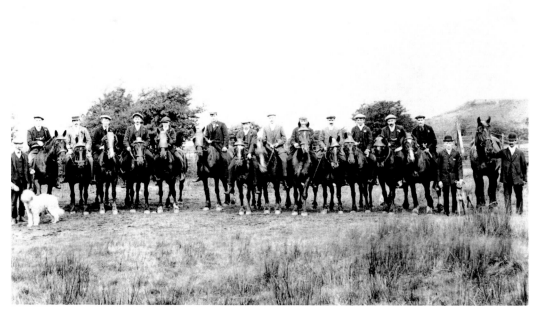

Pit Ponies and Automobiles

Pit ponies from the Vale of Neath pose in the sunshine, c. 1930s. Pictured below, a proud Neath family pose in their new automobile in the early years of the twentieth century.

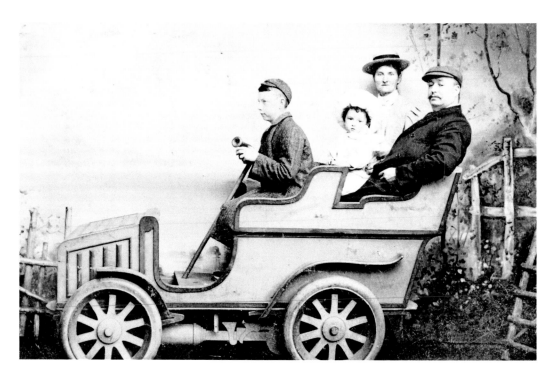

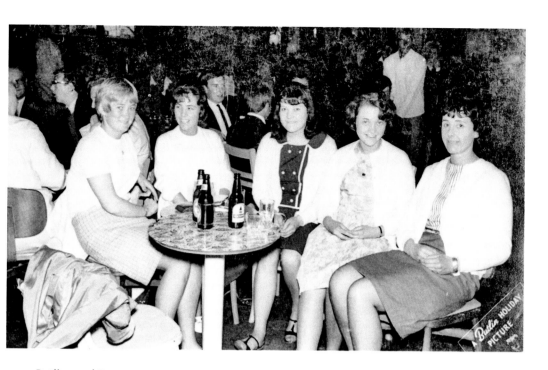

Butlins and Buses

Neath girls at a Butlin's Holiday Camp during the late 1950s. Seated third from left around the table is Margaret Pulman née Warmington. Below, staff pose in the Western Welsh Bus Garage, *c.* 1960s. The garage was located during this time on Neath Abbey Road.

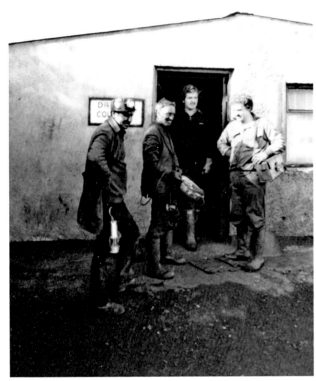

Colliers and Girl Guides
Colliers pose at the Darren
Colliery, Longford, Neath Abbey,
c. 1970s. Girl Guides (below)
from Neath pose on a camping
trip to Penrice Castle, Gower in
the 1960s.

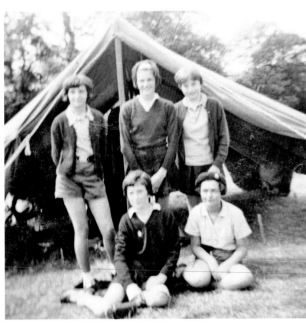

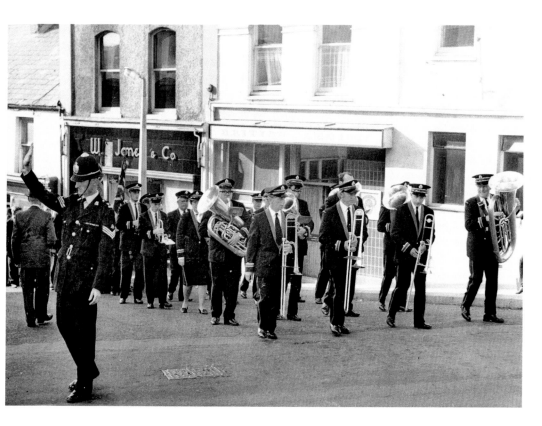

Parades and Outings

Briton Ferry Town Band pass the British Legion in the 1950s. The sergeant controls the traffic. Staff of Llewellyn's Furnishers (below) at their annual outing in the early 1960s. Llewellyn's was located on the corner of Alfred Street and Windsor Road.

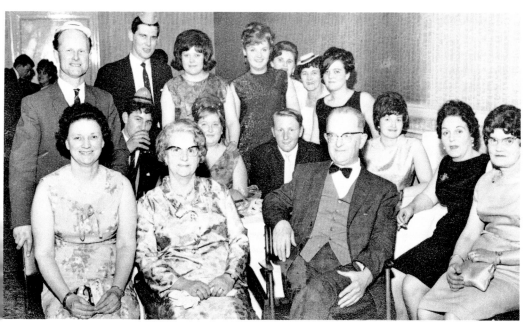

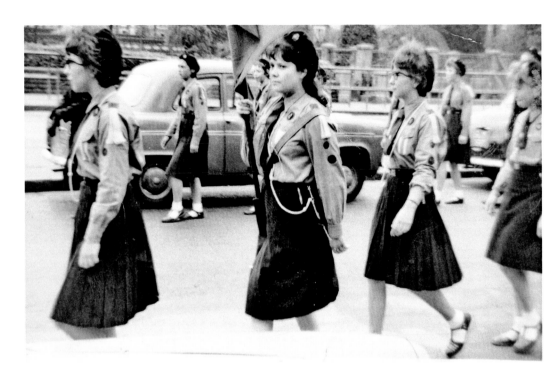

Scouts and Guides

Neath Guides (top) marching along the Orchard Street in the late 1950s. Second from left is Margaret Warmington, a Queen's Guide. Ron Gammon, aged eighteen, being presented with the Queen's Scout Badge during a ceremony held in Skewen in the 1950s.

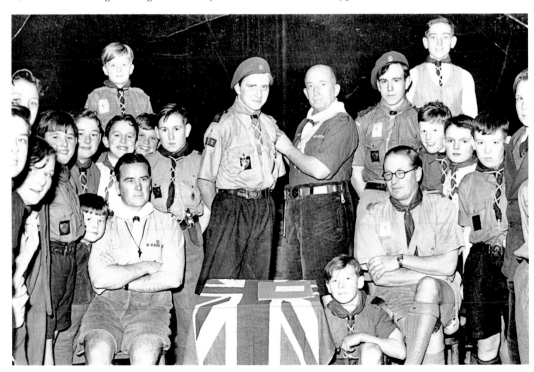

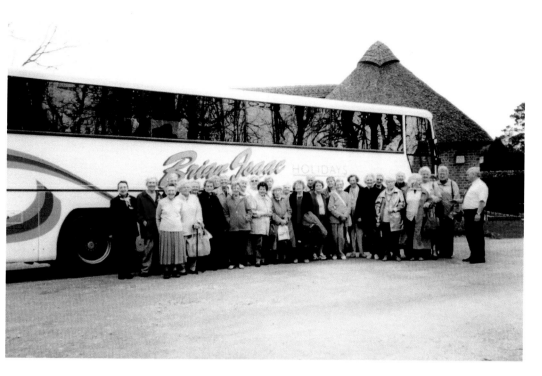

Happy Days

Members of Neath Townswomen's Guild on a trip to Weymouth in the summer of 2004. The Gospel Singers of Orchard Place Baptist Church, Neath can be seen below. This picture taken early in the 1990s: Back row, L to R: Gwyneth Prosser, Hetty Harding, Glyn Hanford, Jenkin King, Ron Evans, Gwladys Bale, Mary Chapman. Front row: Margaret Inggs, Gwyneth Harris, Olive Evans, Dora Williams, Gwyneth Morgan, Maisie Hanford, Nancy Davies.

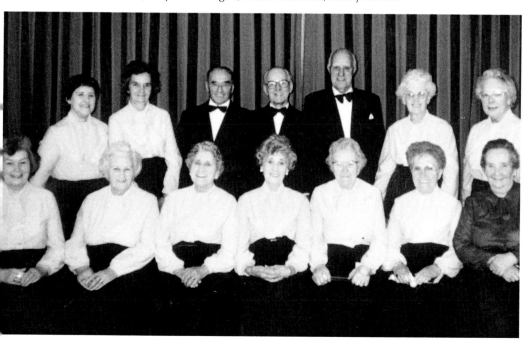

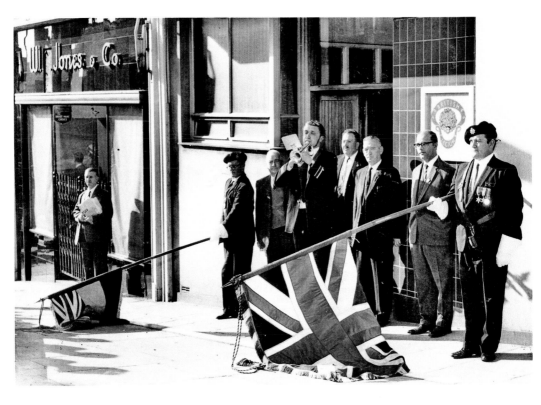

Briton Ferry British Legion

Members of Briton Ferry British Legion remember their fallen colleagues in the early years of the 1960s.

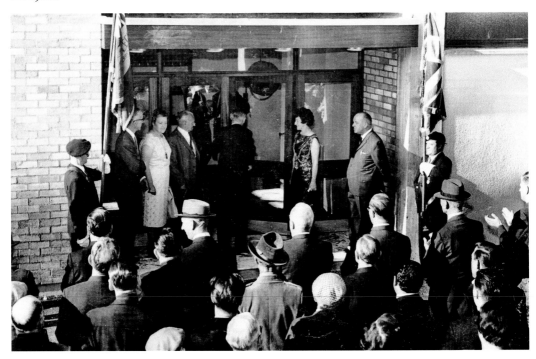

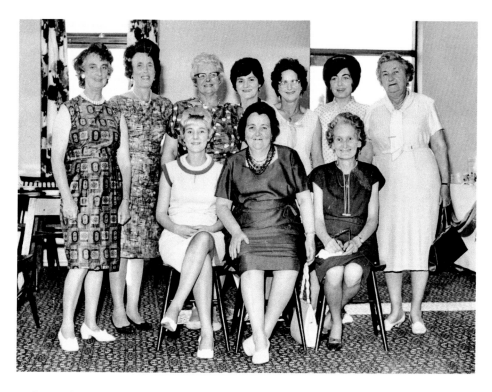

Ladies and Legionnaires
Members of the Ladies' Committee, Briton Ferry British Legion, c. 1960s (above). The Sarn Helen Walk (Banwen to Aberdulais) in the summer of 2005. Plaid councillor, Edward Morgan is dressed as a Roman legionnaire.

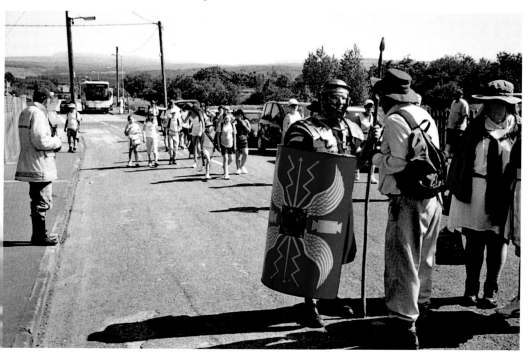

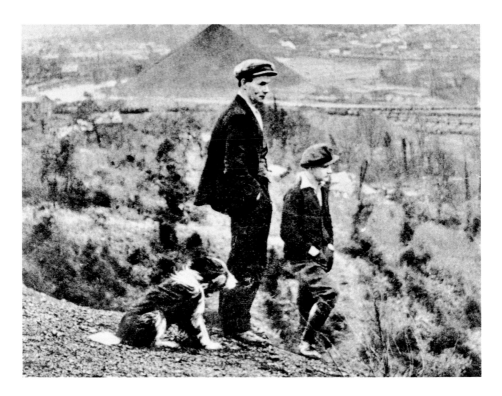

Authors and Anniveraries

Neath author, B. L. (Bert) Coombes and his son, Peter taken in 1941 overlooking Onllwyn Colliery. Bert Coombes wrote *These Poor Hands* in 1939, which became an international bestseller. He lived variously, after moving from Herefordshire, in Cwmgwrach, Resolven and Banwen. He is buried with his wife, Mary, in St. David's New Cemetery, Resolven. Mr Tom Warmington and his wife, Murian express their thanks for the gift to celebrate their twenty-fifth wedding anniversary from members of Briton Ferry British Legion.

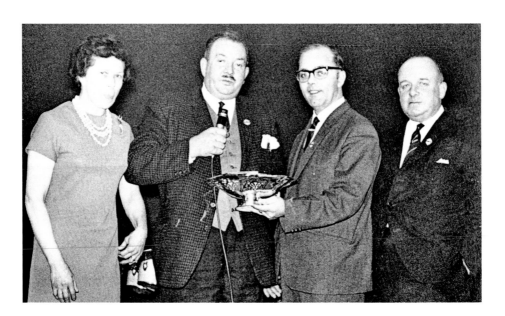

From the early 1900s
The Revds Seth and Frank Joshua of
the Mission Hall, Neath. Both were
involved in the 1904-05 Methodist
Revival in South Wales. The picture
below was taken outside the Gnoll
Lodge, c. 1920, which was located on
Cimla Road.

Hunters and Pupils
The South Wales Mink Hounds hunt on the River Neath at Abergarwed. Left to right: Clive Rees, MFH., Robert Roberts, ?. Pupils at the Gnoll School, *c.* late 1950s.

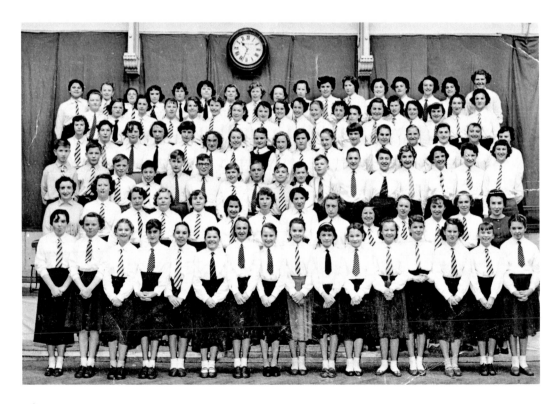

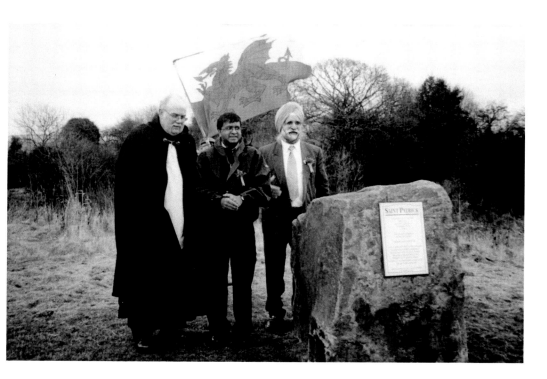

Church Celebrations

The Revd Stephen Barnes, Father Shibu and George Singh at the St. Patrick's Day commemoration in Banwen in 2004. Local historians believe that the saint was born in the village. The photograph below shows people Commemorating Remembrance Sunday in Resolven in 2002. Those among the immediate procession are L to R: Viv Willis, Betty Davies, Jean ?, Joy King, Joan Willis, Alan Morgan and Vicar Norman Hadfield.

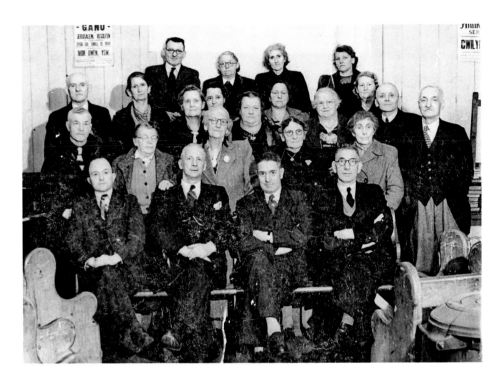

Abergarwed Faces

Members of Ebenezer Chapel, Abergarwed, *c.* 1949. The building was a corrugated iron structure that was demolished in the 1970s. In the picture are Mr Thomas James Powell and Mrs Diana Powell, Mrs Osbourne and Daddo Davies. A house now stands on the site. In early 1970s the Abergarwed Welfare Committee purchased a caravan that was located at Treco Bay, Porthcawl. The caravan was for the use of people in the village to take a holiday. Included in this picture below of the handing over of the key is, Len Davies, J. Williams, Ron Rees, Mr Donald Coleman MP and his wife, Margaret, Mr and Mrs W. Leonard, Irene Reeves, W. Evans, Pheobe Lewis, Gildas Thomas, Dilys Lewis, Michael Webb.

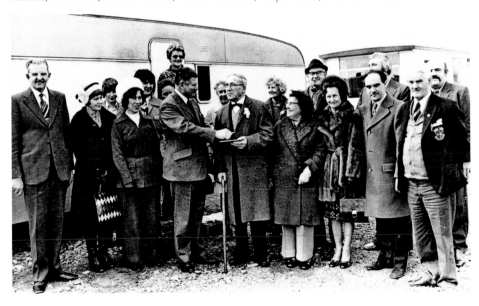

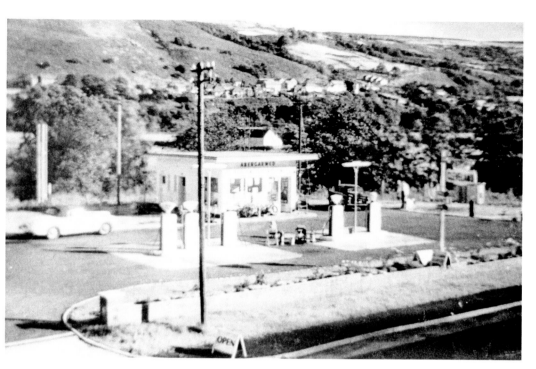

Petrol Pumps Through Time
Abergarwed Filling Station in the
1970s owned by Gildas Thomas.
The garage closed in the late 1980s
and the site is now waste ground.
Right, Mrs Ethel Evans-Guard sitting
outside the home of Horace and
Betty Hutchinson, 6 Lewis Terrace,
Abergarwed. The house doubled up
as a parlour shop and a petrol filling
station. Note the chewing gum
vending machine. The petrol pump
can just be seen on the extreme
right of the photograph.

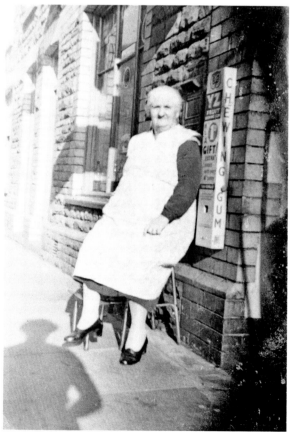

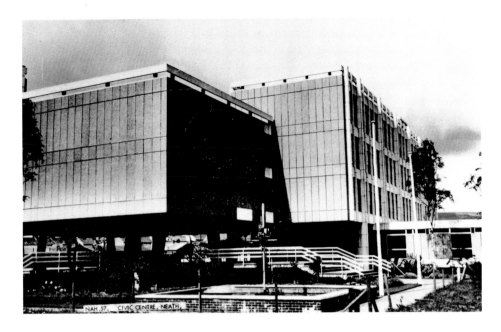

Bryncoch RFC Team 1959-60

Neath Civic Centre taken from Gnoll Parc Road. The locally called 'concrete bunker' was build in the 1960s and demolished in the 2000s. It is an example of modern architecture at its most unattractive. Included in the picture below are, R. Boswell, T. Randall, B. George, M. Lloyd, J. Carpenter, D. Carpenter, L. Thomas, G. Francis, P. Williams, D. Price, T. J. Davies, F. Davies, A. Jenkins, G. Brennan, L. Davies, L. Carpenter, M. Lewis, R. Thomas, A. Richards, L. Phillips, D. Davies, D. Walters, A. Walters, J. Evans, A. Owen, R. Jones, V. Davies, D. V. Davies, D. Husband, H. P. Owen, D. Keelog, B. Milford, G. Edwards, C. Owen.

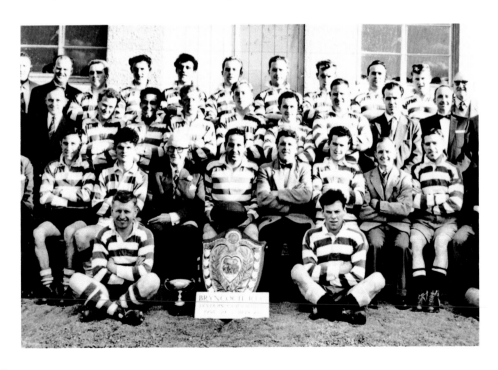

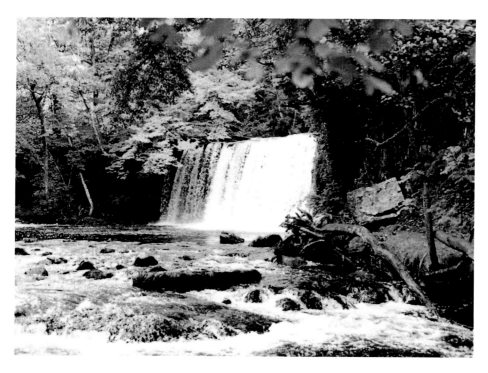

The Upper Ddwli Falls/Aberdulais

The Upper Ddwli Falls on the Little Nedd at Pontneddfechan. The viaduct and aqueduct at Aberdulais. On the left under the first arch is the old toll house for the Tennant Canal. Bargees last paid to use the canal in 1936.

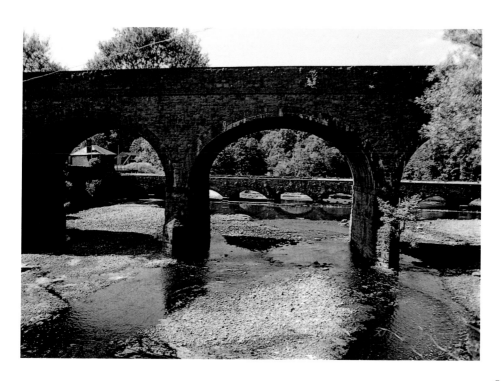

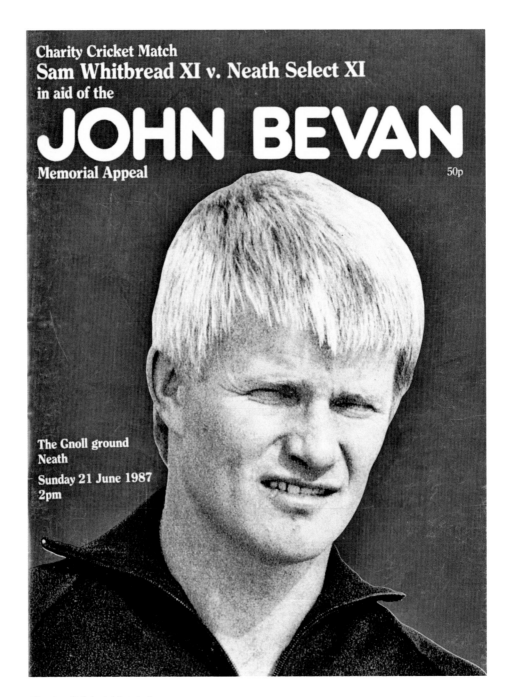

Charity Cricket Match
Sam Whitbread XI v. Neath Select XI
in aid of the

JOHN BEVAN

Memorial Appeal 50p

The Gnoll ground
Neath

Sunday 21 June 1987
2pm

Charity Cricket Match Programme

The programme cover of the charity cricket match in aid of the John Bevan Memorial Appeal played in June 1987. He was treated for lymphoma at the Haematology Unit of the Heath Hospital in Cardiff. John was brought up in Caewern and a product of the Neath Grammar School. He played rugby Union at the highest level in Wales, his club side was Aberavon RFC; he captained Neath's cricket team. He became the Welsh Rugby team coach, a role that epitomised his character. His aim was always to give skill and enthusiasm back to the sports he loved. An unassuming, gentle person, a true Neath sportsman.

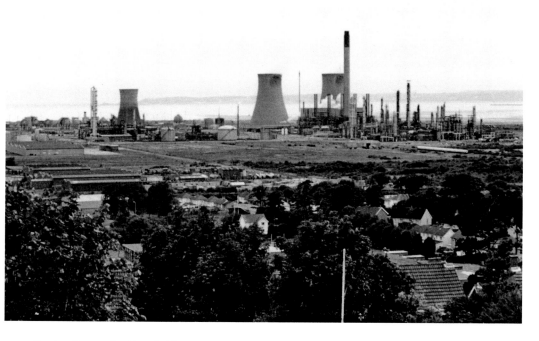

Baglan Bay and a New Bridge
BP's Baglan Bay complex taken from Briton Ferry in the 1980s. Pictured below is the New Bridge at Briton Ferry, *c*. 1960s.

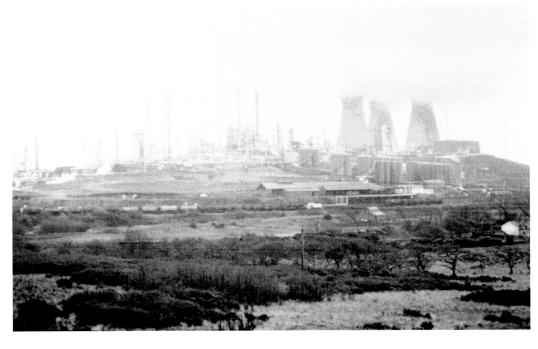

BP Llandarcy

A misty picture of BP Llandarcy taken in the 1980s. Now the refinery is demolished and a village of houses in planned. The demolition is nearly complete below at BP Llandarcy site. What was one of the most important oil refineries in the world is no more.

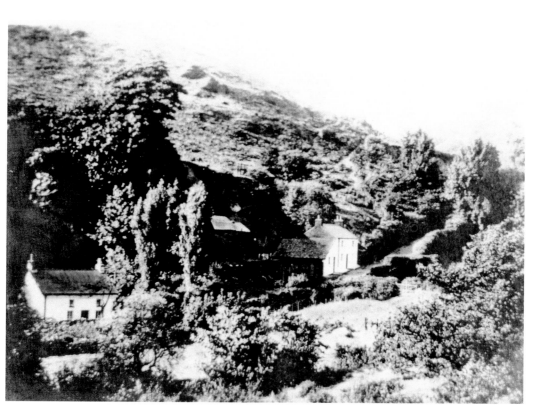

Scenic Views
Gardeners Lane, *c.* 1935.
Remains (below) in 1957
of the Cape Copper Works
at Neath Abbey. The site is
now occupied by the Neath
Abbey Business Park.

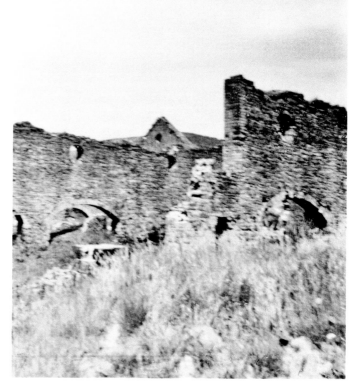

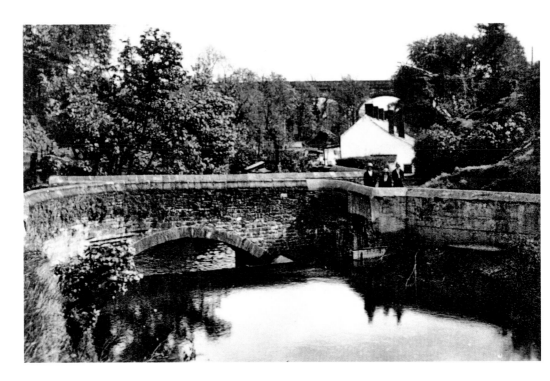

Neath Abbey

An early twentieth century picture of Cwm Clydach in Neath Abbey. In the background is the railway viaduct and the cottages, now demolished, but they were occupied well into the 1950s. They were built by J. T. Price, the Neath Abbey Iron Company's Ironmaster to house workers at his company. The site is now overgrown by foliage. Plas-y-Dinas, Pontneddfechan, *c.* 1900 is shown below.

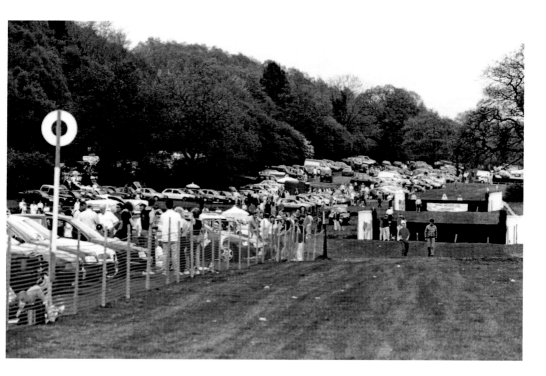

Horse Racing

The point-to-point racecourse at Pentreclwydau. This was the site of the Glynneath Racecourse, which was popular from the 1930s to the mid 1950s. The current incarnation is as popular if not more so, attracting upwards of 5000 racegoers at its May Day meeting, held by the Banwen Miners' Hunt. This picture (above) was taken in 2004. The carriage and four (below) take sponsors of the May Day races at Pentreclwydau to the meeting in style. This picture was also taken in 2004.

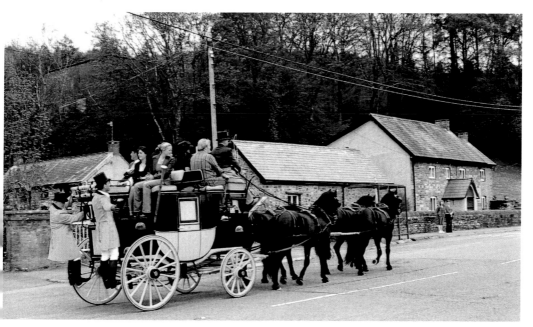

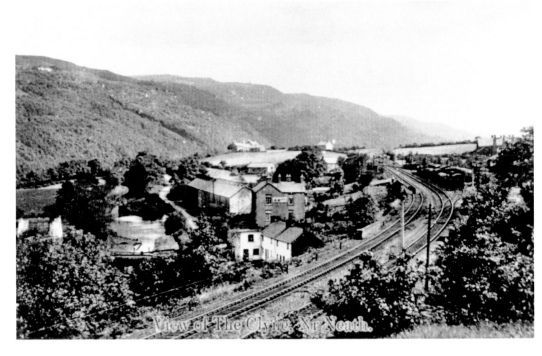

Two Old Views

The village of Clyne and the Vale of Neath Railway (the Pontypool Road). On the extreme left of the picture are the Cefn Mawr Sidings; in the middle of the picture is the Whitworth Arms, c. 1940s. Onllwyn Colliery, c. 1930s is shown below.

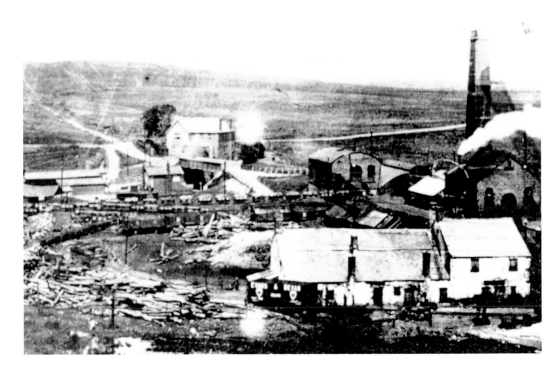

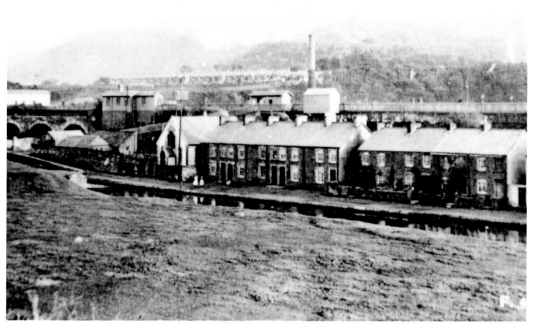

Neath Rail

A view of the Canal Bank, Aberdulais; the railway halt can be seen in the middle of the picture, the stack of the tin works to the left the spire of St. Anne's Church in Tonnau. A view of Neath Station (below) before it was modernised.

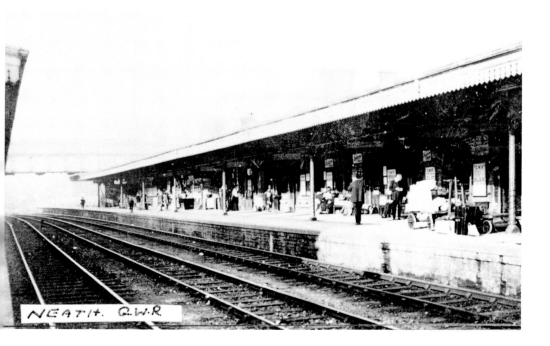

NEATH. G.W.R

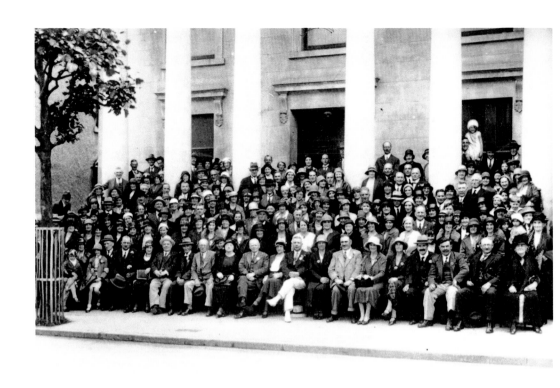

Town Hall and Memorial Gates
A large gathering poses outside the Neath Town Hall, *c.* 1940s. Neath's War Memorial Gates, below *c.* 1930s.

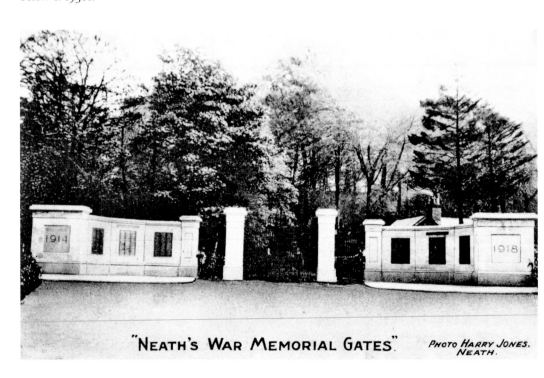

"NEATH'S WAR MEMORIAL GATES". PHOTO HARRY JONES. NEATH.

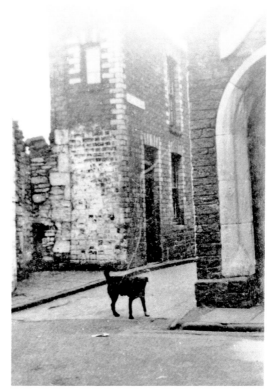

Different Views
Castle Buildings, *c.* 1920s and Swiss Cottage, Longford in the snows of 1982.

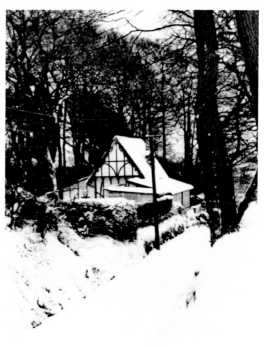

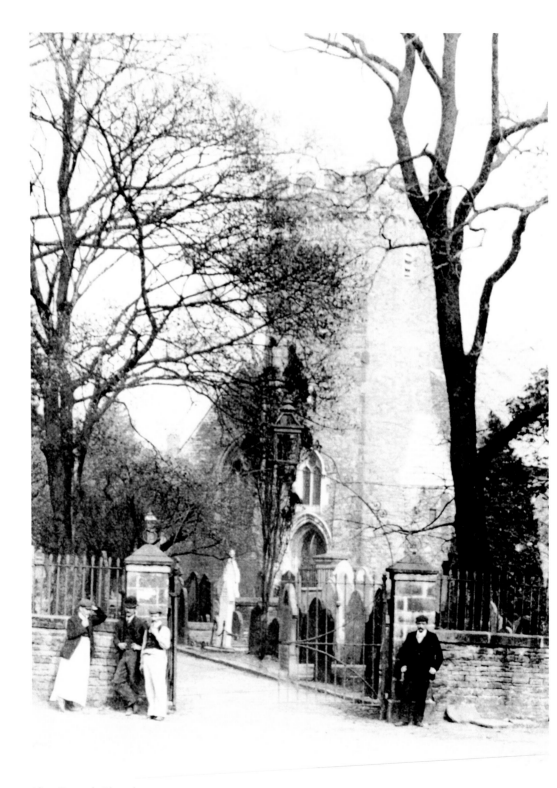

Llan Gatwg's Church
Llan Gatwg's Church, Cadoxton, *c.* 1920s.

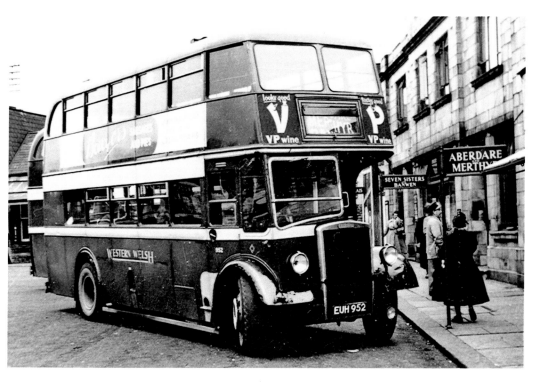

Views Around Neath
A Western Welsh bus at Station Square in the 1960s, and the approach to Skewen Park, c. 1940s.

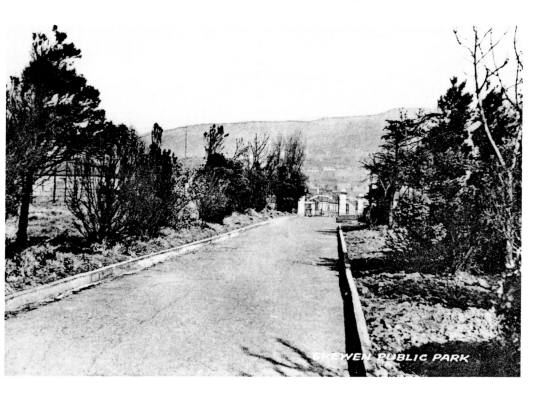

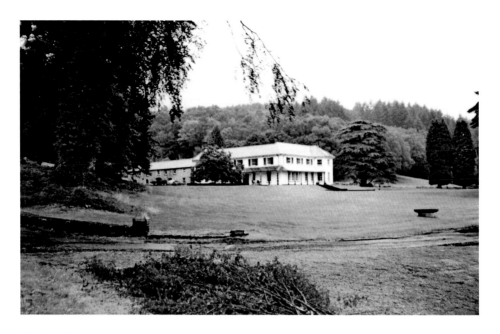

Historic Houses

Rheola House, the only remaining 'big' house left in the Vale of Neath. This picture was taken in 2006. The owner, Mr Howard Rees, is undergoing work to refurbish the house and its surrounding land. The image below is taken from from a nineteenth-century print of the Gnoll House. It was made famous as the home of the Mackworths. It was demolished in the 1950s. The grounds are now in public ownership for everyone to enjoy.

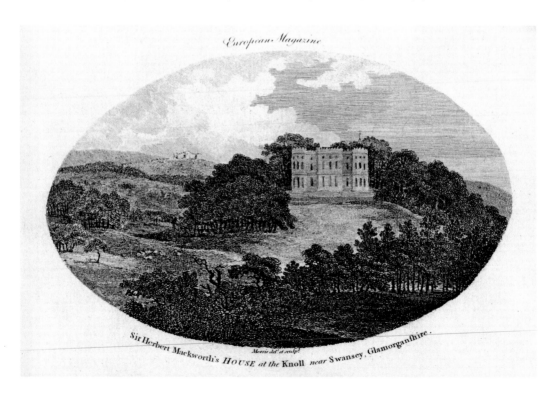

European Magazine

Sir Herbert Mackworth's *HOUSE* at the Knoll *near* Swansey, Glamorganshire.

Morris del' et sculp!